the ad-makers

How the Best TV Commercials are Produced

Tom von Logue Newth

I L E X

THE AD-MAKERS

First published in the United Kingdom in 2013 by
ILEX
210 High Street
Lewes
East Sussex
BN7 2NS

Distributed worldwide (except North America)
by Thames & Hudson Ltd., 181A High Holborn, London
WC1V 7QX, United Kingdom

Publisher: Alastair Campbell
Creative Director: James Hollywell
Executive Publisher: Roly Allen
Managing Editor: Nick Jones
Senior Editor: Ellie Wilson
Commissioning Editor: Zara Larcombe
Art Director: Julie Weir
Designer: Grade Design

British Library Cataloguing-in-Publication Data

A catalogue record for this book is available
from the British Library.

ISBN: 978-1-78157-032-6

Printed and bound in China

Colour Origination by Ivy Press Reprographics

10 9 8 7 6 5 4 3 2 1

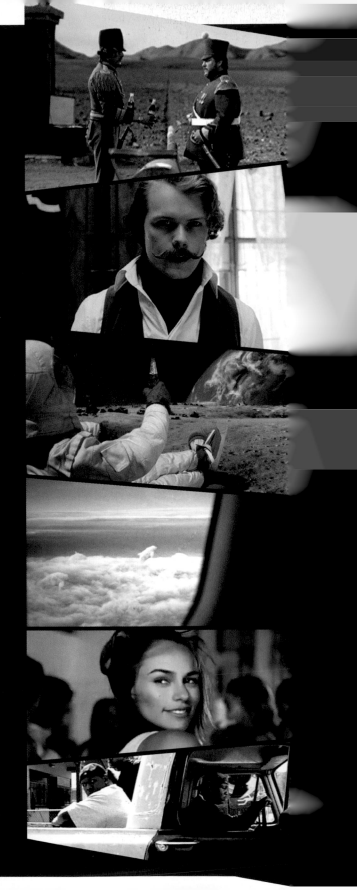

the
ad-makers

Contents

Introduction

Written advertising is as old as commerce itself. The development of radio, television, and cinema in the twentieth century, however, provided businesses with an exciting and dynamic new way to promote their products and services. While cinema relied primarily on advertising forthcoming features—the first "trailer" was shown in 1913—and early radio shows were usually backed by individual sponsors, it was the explosion of broadcast television in the 1950s and 1960s that created the moving-image advertising climate with which we are familiar today.

Initially, many television shows relied on the radio model, being sponsored by a single business or product, but it became quickly apparent that far greater profits were to be made by selling smaller parcels of time to different advertisers. And so the "commercial break" as we know it was born, a pause in the scheduled programming for a brief string of thirty-second films, promoting different products.

Advertising agencies predate the moving image by approximately a century, and so by the time of the television explosion of the fifties, they were eager to provide companies with the expertise required to capitalize on this new outlet. Typically, a business will employ an advertising agency to create its commercials across a number of different platforms. The commissioning company will usually provide a basic outline of what it hopes to achieve with the advertising campaign, what message it wishes

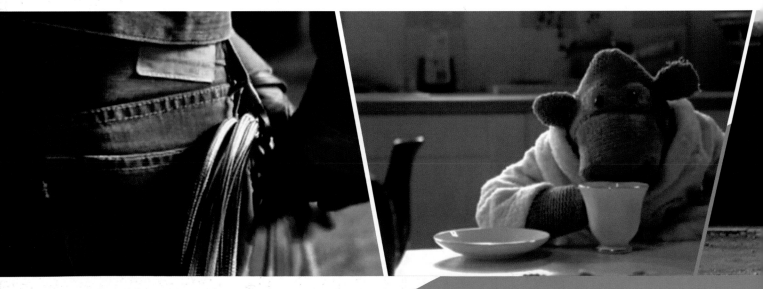

to convey, and which audience it hopes to reach; the agency will then refine these criteria, apply its own creative expertise, and flesh out a practical plan of action.

These conventions remain. First, however, the advent of digital recording technology and TiVo hard drives made it increasingly easy for consumers automatically to skip the advertisement breaks altogether. Then the mobile device took over, screens became both bigger and smaller, and a whole plethora of new platforms was born. The thirty-second TV commercial is far from obsolete, but its target audience can now more frequently be reached in a far wider variety of ways.

OPPOSITE LEFT:
Levi's Type 1 Jeans "Runaway Car" (BBH/ Traktor Films).

OPPOSITE RIGHT:
PG Tips "The Return" (Mother/Rattling Stick, d. Daniel Kleinman).

BELOW LEFT:
Coca-Cola "Border" (Weiden+Kennedy/ Furlined, d. Adam Hashemi).

BELOW:
Doritos "Tracker" (Independent Superbowl commercial, d. Marcus Dunn, Jonathan Darden).

TV Advertising in the Internet Age

Traditional short-film type advertisements have found a home on video channels, playing in front of video clips or in page banners. Others have stretched the format or been presented as episodes. The ease with which videos can be watched, sent, linked to, and embedded has allowed the form to develop in ways that are free of traditional television requirements and conventions. While the mobile device in the back pocket is a well-established platform, however, the emergence of the Xbox as a catch-all media device, and the rise of the SmartTV, suggest that the screen in the living room is not going away.

The Internet age has added an extensive new dimension to the agency's role, also, as they catch up with the potential of virtual advertising. Frequently they will find it useful to subcontract to specialized companies who have proved themselves adept at handling commercial distribution across social media, search engines, video sites, and other interactive spaces.

However, whether intended to play before a YouTube video, in the Super Bowl half-time break, or in the back of a New York taxi, the actual process of creating these short films remains largely unchanged. Once the creative plan has been sufficiently structuralized, the film will be physically shot or digitally animated, and then subjected to the appropriate post-production polishing.

The blooming of ways in which media is today consumed has allowed advertisers to stretch their imagination in terms of form, be it drawing from the popularity of documentary approaches and viral videos or exploiting interactive potential. Personal devices become a direct one-on-one conduit to the consumer, who may as well watch an entertaining advertisement as any other YouTube video. This demands a shift in the way advertisers relate to their audience, as the relationship between the two become more apparently personal.

Stages from Conception to Distribution

The process of creating a commercial remains basically unchanged. The client works out its message, audience, and selling points, to a greater or lesser extent, and presents them in a "brief" or conceptual deck. The creative director of the chosen ad agency will use this, the messaging, and the overall conceptual deck to develop a mass of different ideas and numerous scripts. With perhaps the best three, the agency will canvas production houses and look at directors' reels. Perhaps three directors will be selected, based on talent and availability, and each of them will produce a treatment. By this stage, decision-making has to go through a number of levels, from agency to client, but once a decision as to the director has been reached, pre-production will start almost immediately.

Effects specialists are frequently brought in at this stage to make sure the ideas are going to be possible to realize in post and, during shooting, to ensure that the physical environment can be smoothly translated to the virtual, but otherwise the filmmaking process remains more or less unchanged. Storyboards are done and shots worked out, the production design department start sketching and building models, and casting and locations are firmed up. The shoot is timetabled, then frequently thrown off by the unexpected—but the footage is captured, and then sent to a post-house. Editing and the usual polishing of image and sound are now often augmented by some sort of computer-generated imagery or manipulation, sometimes involving more time and manpower than the shoot.

There has always been a lengthy—and often frustrating—process of exchanging notes and changes back and forth between the client, the agency, subsidiary agencies, the production company, the director, and the editing team. The growth of social media and digital outlets means that for the client companies and advertising agencies, there is now a dizzyingly increased range of factors to be taken into account. But for the creative and the ad-maker, it represents the opening-up of a vast range of possibilities as to what an advertisement can be, how it can be made, and through which media it can be presented.

The following pages will trace a path through this complicated procedure, from corporate conception and brand identity via the back-and-forth creative procedure with advertising agencies, new media agencies, and production companies, to the varied and complex forms of post-production and digital effects work, and to the final placement and utilization of the advertising film.

OPPOSITE LEFT:
Guardian "Three Little Pigs" (BBH London/Rattling Stick, d. Ringan Ledwidge). Copyright Guardian News & Media Ltd 2012.

OPPOSITE RIGHT:
Specsavers "Eerie" (Specsavers in-house/ Rattling Stick, d. Daniel Kleinman).

"The blooming of ways in which media is today consumed has allowed advertisers to stretch their imagination"

Chapter 1
Corporate Conception to Creative

To begin the process of making an advertisement, there must be a brief formulated by the client corporation. This is the brand message that needs to be conveyed by the overall advertising campaign, and it will often include specific requirements for the filmed commercial. It may well also include potential problems, selling points, demographic information, and anything else that defines the marketing mission. Usually, it is literally brief.

Overall Campaign Plan

The brief is handed over to the chosen ad agencies, who bid for the job, and the more specific it is, the easier it is for them to address the client's needs. Often the client company will involve the creative director of the chosen advertising agency in then refining the brief, because the particular skills and awareness of the experienced agency creative can be invaluable in determining at an early stage what may or may not have rich strategic potential.

Product Identity, Message, and Audience

Some sectors of business, and even companies within the same sector, will know more than others about how they want to fashion their advertising. Fashion companies, and often clothes companies in general, frequently have a relatively well-defined conception of their campaign, whereas companies that make a product, electronic or otherwise, most usually require more research and a greater length of time to determine how best to present that product, as well as whom they want to target. In the former instance, as a result, the company may well have its own in-house advertising division, and possibly even a production department; in the latter, the company's brief will be based

more on demographic information, and their own ideas about what is different about their product, leaving the more creative components to the agency.

The Agency Takes Over

Once the brief is handed over, the agency assumes most of the control. It is their responsibility to realize the client's mission, from conception and production to delivery. The client remains involved in the decision-making process but more as a final arbiter, and they will typically employ an agency in whom they have faith, and whom they believe can fulfill their marketing aims.

One of the agency's creative teams will take the brief and work over countless ideas, and then present them to the creative director. A larger agency will have several teams, and sometimes they will present ideas to compete for the same brief. The production team at the agency is frequently involved at this stage also, to start thinking how these ideas can best be presented, so that when the agency returns to the client with their proposal, they can explain to some extent how the commercial will be made.

There will also be a planning department involved at the agency, who immerse themselves in research and information-gathering, so that they can end up knowing almost more about the product than the client does. Their work is a fundamental resource for the creative department.

Refining the Conceptual Deck

The creative team has to come up with a staggering number of ideas, and so their process is also one of immersion, thinking in, around, and about the product or brand. The creatives will work individually, in pairs, and in groups to come up with as many ideas as possible, most of which they will reject themselves. They will then submit these ideas to the creative director, up to sixty or seventy for one spot, depending on the number of teams working on the project. More ideas will be thrown out, sometimes all.

The creative director then submits the agency's ten best ideas or so to the client, who will often select between one and three with which to go forward. It is not uncommon, however, for the client to reject all of the submitted ideas, in which case the agency must start the whole process over again. It is important for the creatives to be able to weather a large amount of rejection, because they spend a lot of time putting a lot of work into a lot of ideas, to which the response is most often "No."

Luke Mugliston: Agency CEO

As CEO of CST The Gate, Luke Mugliston draws on a wealth of experience from both client and agency side. He was running major brand accounts for Publicis when global investment giant Fidelity recruited him as marketing director; from there he moved to Aviva (formerly Norwich Union) to oversee their enormous—and highly successful—corporate rebrand, where he pioneered social media techniques among other innovations, before returning to agency side to head up CST The Gate with creative director and industry legend Dave Trott.

Career Path

When I left University I had no idea what I wanted to do. Funnily enough, advertising was one of the careers that I absolutely rejected because I saw a documentary about Saatchi & Saatchi in around 1995 or so. It was about graduate trainees and how they got into the business, and what the business was like. I just thought it was ghastly and full of jerk-offs and I'm never going to do that, and I'm never going to go into the financial sector either, for that matter. But it dawned on me that I would eventually have to start a career, and someone who worked in the advertising industry said that they thought I'd actually be quite good at it—I studied English at school and was reasonably adept at literary criticism, and had a degree in modern languages. I guess I was subconsciously interested in the whole nature of communication.

I thought, I need to get a real job and not squander all this education, so I answered an ad in the *Guardian* newspaper's Media section for a junior assistant/coffee-pourer at a small London ad agency. I wrote a succinct letter, quite a good one, and I got an interview. Lots of people applied, but my interview was okay. I managed to get through to a second interview where they whittled it down to five from over a thousand applicants (this was about 1996, at the tail-end of the recession). I then did well in my second interview and basically it got down to me and a guy who got a First class degree from Oxford in English, which I certainly didn't have. But because I'd done sports at an international level, been committed and trained and was very competitive, in addition to some internships where I'd been dealing with difficult people in difficult environments, they thought I'd be a good fit and I got the job.

That's how I started in the industry— September 1996—in Golden Square for a small agency called KWS. It was a private company, set up by ex-Unilever and JWT people, lovely people. There were about twenty-five of us—you were shoved in at the deep end, and if you survived, great, but if you didn't, you were out. You learned on the job. I loved it and had a fantastic time.

They sold their agency to Publicis group, one of the top five agencies at the time, who took KWS and merged it with another agency, where I worked on more accounts and grew up on that. After a couple of years I got plucked out of there into Publicis itself, becoming a board account director, and subsequently got snatched up by an investment company client who made me an offer saying, we like you, we're restructuring our end, we want some leadership and you understand our business. That coincided with my having children, and they made me an offer that I couldn't refuse. I was there about four years, and it was good and interesting. I had every intention of leaving after two years and going back to the agency side, but then that job led to being global brand director at Aviva, where we did some major advertising featuring Bruce Willis and Elle Macpherson and other celebrities as part of the campaign transforming Norwich Union into Aviva. It was very, very visible and a big success, in many senses of the word. More than just advertising, it involved learning how you work across the organization within a big, complex FTSE 100 company, in different markets and so forth.

A few years later my phone rang from someone I knew who was a non-executive director of my current holding company and they said, we've had this merger, we'd like some leadership for this place, and we think you're the guy to do it—you'd always talked about going back to agency side. I'd been out of the [agency] business for about eight years by this time, but I was dealing and working with Abbott Mead Vickers and other agencies, and obviously still in

the marketing/communications sphere. So when this guy asked if I wanted to come back, I'd done three years or so at Aviva and felt that I'd done an awful lot there and it had been really good, but that it might potentially be the pinnacle of something for me at that organization. I wasn't quite sure where I wanted my career to go next, and when this turned up I thought it might be a great opportunity to be chief executive of an agency that needed some sorting out, with some great talent and some interesting accounts, but also some management issues. So that's what I'm doing. That was ten months ago now that I started [late 2011], so I've been in this role, back on agency side, for ten months, and it's great. It's challenging, but it's great to be back.

Don't knock It Till You've Tried It

You still come across an awful lot of self-important, tricky people—it's not to say that my initial view of the industry and agencies and some people within the industry wasn't intact over the years, but as you get older you realize that every industry has those sorts of characters. There was a certain arrogance, a certain type of behavior, that I felt was off-putting. When I first started I felt much more comfortable because I went to a smaller business, rather than a big agency with a conveyor belt of graduate trainees. The people with whom I was working were lovely, and they were bright, and there was a real sense that because it was a private company, if you behaved with integrity you'd get rewarded. I was surprised by how early you were given responsibility and authority and ownership of client relationships—a lot of faith was put in you. You felt you were trusted, and it felt a lot more grown-up than I thought it would be.

Having said that, rapidly—in my first week—it dawned on me that this was a lot of fun for a twenty-four-year-old. On day two we worked on the LG account —a big 3M company, which then was kind of a sleeping giant in the UK but big internationally (and now it's even bigger). The first brief we had was a product recall for a fridge/freezer that was about to go onto a consumer show, because it was electrocuting people. So my first experience in advertising was this emergency brief to do the product recall, to get this product back out of the market, and do damage limitation for the forthcoming episode of that consumer show. That was interesting in its own right, but the irony was that the global tagline for the organization at that point was "Technology with the Human Touch." In that first week, in that first meeting, you suddenly got an insight into how ludicrous—and very serious—all this was, because absolutely there was business involved, there was money involved, there were reputations on the line—but also just how funny and strange and bizarre the whole world of communications could be. So that was very exciting in the first week. Immediately the job was very stimulating and the people I was working with were great too. It was very different from the image that had been set out in the documentary for me.

I was also asked to work with an art director on a cosmetic account, and my job was to ring up all the modeling agencies in town and get all their books in; then I had to sit down and spend an afternoon with the art director deciding who was the shortlist of talent that we wanted to get in, and do test shots of, to cast as the main star of our forthcoming advertising campaign. That, as a young man, ringing up models, getting them in, taking their contact details . . . doing that, I just thought, I can't believe I'm being paid to do this, this is fantastic.

OPPOSITE: Aviva "Names" (AMV BBDO/ Serious Pictures Limited, d. Vaughan Arnell).

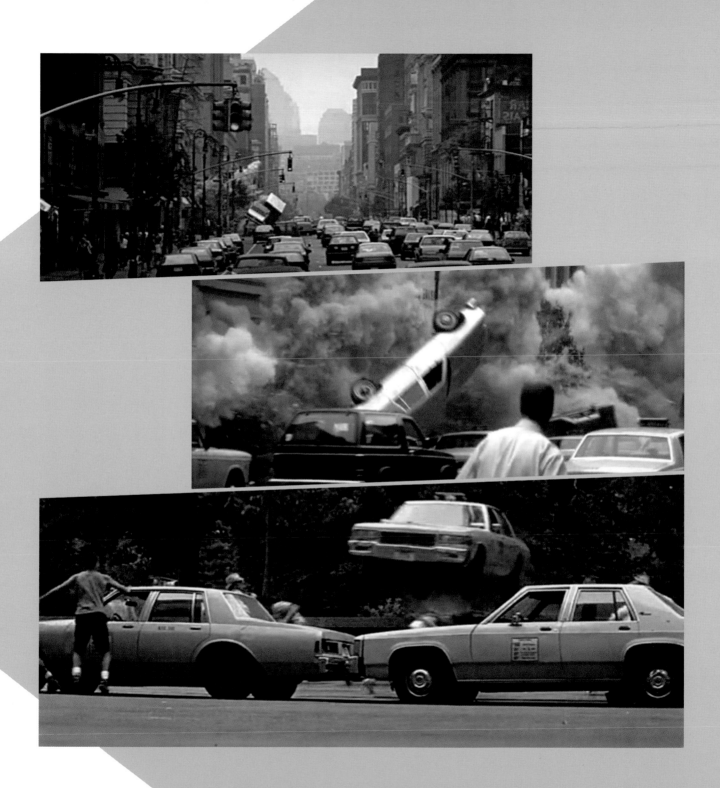

An Exciting Industry

Then the whole production process of making an advertisement is very exciting. There are things like doing market analysis, customer research, competitive reviews, strategy etc., but when you're on the agency side there's also that fun of actually creating the ideas and working on that whole process. It just feels exciting. You go to shoots, and you're part of that industry. You're doing lots of interesting and varied things, and your working week can be thrilling. So very, very quickly, starting as someone who didn't really know what they wanted to do, it suddenly felt that this was an innately varied job. I felt that it suited me, and actually if you're reasonably good with people, and you listen well, and you have a point of view, and you're helpful—because it's a service business in so many respects—then you can do well here.

You end up building relationships with clients, and you get the satisfaction of those clients trusting you from a very early age. The other thing that was apparent to me, compared to people I knew working at other companies, was how quickly you got fronted at a very young age to present to very, very senior management in client organizations. When I finally went to Fidelity, for example, it struck me that I had frequently presented to the highest levels of management, whereas employees who had worked there all their professional life had never actually met some of their leaders. Working on agency side is privileged in the sense that you do get in to see these people for whom advertising, especially if you're a service business, is their equivalent

BELOW: Aviva "Plymouth Football Fan" and "Silver Surfer" (AMV BBDO/HIS London, d. Declan Lowney). Courtesy of the Advertising Archives.

of a high street presence. All of that made me think, this is challenging, this is interesting; there's the excitement of winning new business, there's the tragedy of losing business (hopefully not too much but, you know, things happen). It's a very exciting world, and I just got swept up in that. Also you make really good friends—you meet people who are like-minded and often very bright, from all walks of life, and I just had a great, great time.

Aviva

The rebranding of Aviva wasn't just about the advertising; it was an enormous brand restructure, and a huge corporate action, as you can imagine. It's a massive operational and emotional undertaking for an organization of Aviva's size to change their name. We were trying to create something new and use it as an opportunity to regenerate the organization, to create a new experience for customers, and to effect literal behavior changes within the organization.

There were of course significant risks. The company was a number one player in its home market, in a long-term business, and people to varying degrees had a fond-ness for the legacy brand name Norwich Union. The nature of the business is all

about looking after customers' money and providing constancy, trust, and reliability. Keeping customers confident and happy is crucial to its commercial success. So it was a tightly-run project up through all echelons of the organization, right up to boardroom-level approval, and involved the hard work and collaboration of hundreds of people.

From a marketing effectiveness perspective, we approached the rebrand with a great deal of responsibility as we were deploying significant sums of money and needed to report regularly on progress. We set up a detailed dashboard of KPIs [key performance indicators] and made regular changes to our promotional plans based on the data we were getting, e.g. recall of message, differentiation, consideration levels, etc.

The whole process was well underway when I came on board. You're part of a big team of people. Part of my responsibility was to look after the advertising and make it happen; deliver it, set up the metrics around it, report on that, and make sure it happened without a hitch, including the TV and the posters and the press and all the subsequent strategic frameworks and general brand management duties.

The reason I was hired was because they needed to deliver this, and for about eighteen months beforehand they'd been doing a lot of research around the world into customer insights about what people wanted from financial services and organizations like Avivia, what their attitudes were in different markets, what the strategy around positioning this company could be, and how would that benefit the business and lead to getting a commercial advantage. That involved research companies around the world, it involved branding companies, advertising agencies, and a central organizing team, which comprised business unit heads, project managers, all of the various people who are responsible for the different channels of communication.

They'd made progress on agreeing on the name change and done a lots of due diligence around mapping out the benefits of that. I inherited a lot of that good work, and my job was really coming in to deliver and make it happen, and to make sure that that investment was then used as a springboard, to use the momentum to spread best practice and enable people to embrace the strategy in all parts of the business. You get these big organizations which refer to themselves as "matrix" organizations, where it's often all about influence and leveraging your own personal network. For someone like me who has a fairly short fuse in terms of bureaucracy and just wants to get things done, you have to employ a healthy dose of diplomacy in taking the lead, even though you don't necessarily have the overt authority over everybody. So that was interesting as well because you have to say, right, this is what we're trying to do, and you set up a vision for what we're trying to achieve, you set up a rationale for that, and the commercial support, and then you just encourage people to behave in a more unified way than perhaps they had in the past. So all that continued to be interesting after the thrill of delivering what was such a major advertising campaign: in fact *The Times* referred to the whole program of activity as "arguably the slickest rebrand in UK corporate history."

A Delicate Balance

When I came into Aviva, the first thing that I had to do was to get the creative elements for the campaign into shape. There were TV spots that we had to edit into the final formats to go onto air, and there was press, poster, and digital work to be developed as well. The big issue with that was when you get to the final stages of doing such a big campaign, and you get very close to the hard deadlines for approval

grad to **St. Petersburg**

an to **Craig**

ich Union to **Aviva**

Arpanet to **Internet**

Bamboo Harvester to **Mr Ed**

Norwich Union to **Aviva**

Britain's biggest insurer is changing its name. **AVIVA**

William Cody to **Buffalo Bill**

Finisterre to **Fitzroy**

Norwich Union to **Aviva**

Britain's biggest insurer is changing its name. **AVIVA**

ABOVE & LEFT: Examples from Norwich Union's corporate rebrand to Aviva (CST The Gate).

"People might not have an opinion about P&L, but everyone will have something to say about advertising."

LEFT: National Accident Helpline "Underdog" (CST The Gate/ Aardman Studios)

of the creative work, you suddenly get an awful lot of minute attention to detail and a more focused realization among the leaders of the organization that this is suddenly very real, and it's going to go out there, and that once it's out there you have to deal with the consequences. Because there are a lot of customers and a lot of money is involved, and because it's a FTSE 100 company, people will be saying, is this a judicious use of all this money? So suddenly everyone gets understandably a bit nervous. There's a great deal of internal stakeholder management, and to-ing and fro-ing with the agency, which is very important. The temptation at that stage is to make lots of little cuts that might have lots of significance from the client's point of view, but the agency are there to remind you that the ad has got to work in the way it was originally designed to work, and that by making lots of cuts you run the risk of losing that perspective on how the thing will actually perform in the real world, set in a busy context.

So there was a lot of internal engagement to get people to understand what we were trying to do, to realize why we we're doing the things that we're doing, and to stop the commercials being cut to shreds through lots of intervention by lots of people. Obviously every now and then someone makes a perfectly sensible comment and you go, well actually that's an improvement. The skill is to work out where it is an improvement, and where it isn't an improvement, and where it's something that will detract from the original idea, or will just increase the cost of it. It's a combination of getting it absolutely, perfectly right, but also not cutting it to shreds.

From the agency side, I had an appreciation of what the role of the advertising is, how it would work; but also having been a client for a few years before that, I knew the nature of client organizations. It's a highly diplomatic role, both understanding the complexities of the client's side of things, but also having an appreciation for what the creative work had to deliver.

Agency Side and Client Side

When you're on agency side you naturally put all your efforts into the process of creating campaigns. Then you make your presentation to your client, and hopefully they buy it, and you walk away from that client meeting feeling very happy with yourself. Of course, when you're client side, you have to keep it sold. At every point along the way you might get challenges from financial directors, from operations directors, sales teams, legal teams—everyone's got an opinion when it comes to advertising. People might not have an opinion on the nuances of a P&L [detailed financial statement of profit and loss, usually for a fiscal quarter], but everyone, at whatever level in the organization, will have something to say about advertising.

The biggest lesson for me going back to agency side was in helping the clients with whom I work, to keep the idea on the table, to keep the campaign and the creative work sold, through better understanding of the factors that can be at play within their businesses. So going back on agency side, what I'm getting my guys to do is to have a better appreciation for what it's like to be a client, and help support them as individuals within their organization. I remember thinking when I was first agency side, what does the client actually do when they're not in meetings with us. Suddenly to have an appreciation of everything else you have to do when you're client side has been a really useful lesson to bring back to the agency.

It was interesting: I could see it right away. From the first few meetings I had with clients, I'd be asking them what was really on their minds. It'd be nothing to do with the advertising, but all to do with

internal or commercial pressures that they were facing over any number of things, so having an understanding of what they go through has really helped us build better relationships with our clients. At the end of the day, you produce creative work, but you also build relationships with people who want to work with you. You'll go through lots of individual battles, but actually if you're helping them win the longer term war, then they'll value you for that. Those long-term relationships are very important, so ideally people will come to think of us as more than just their communications suppliers, and more like their secret weapon.

Philosophies

The philosophy of CST The Gate is built around something we refer to as "predatory thinking." There are hundreds and thousands of agencies all chasing what can feel like a relatively small number of clients with budgets. Agencies traditionally struggle to stake out their territory and define what's different about them as an agency. Many agencies will latch on to the latest thing, so you get a fair bit of "we're all about igniting brand conversations," which is fine, but often feels as if we are all dancing on a pinhead.

When you talk to people who help manage pitches and put together shortlists of agencies for clients to review, they'll tell you that apart from ours, there are generally only two philosophies that stand out, or are memorable, as far as agencies are concerned. One is "brutal

BELOW:
www.cstthegate.com

OPPOSITE:
The team at CST The Gate.

simplicity of thought," which Maurice and Charles Saatchi talk about religiously, because great communication is always really simple and really clear. In all their procedures and conversations and creative development, they use this as their guiding light for campaign creation, and it works very well for them.

The other philosophy that people remember is the one adopted by TBWA, which is called "disruption," all about breaking category norms, fundamentally, and standing out. The third philosophy, our way of doing things, which we are told gets remembered, is predatory thinking. In fact, it's nothing dramatically new; it draws upon things that most good agencies do anyway, whether or not they actually articulate it as a process. It's fundamentally about trying to change the context to create an unfair advantage and being outcome-focused.

Predatory Thinking

A nice example is the problem of dealing with poor eyesight in Africa. A billion people in developing countries have defective eyesight. But it isn't lack of glasses that's the real problem, it's lack of opticians. Rather than get a lot of costly opticians into poor areas, there was the ingenious invention of putting fluid into these very cheap glasses so that people can actually adjust them themselves. The point is that rather than saying, how can we recruit, train, and deploy a lot of opticians for these places, to come from a different angle and create a product that's easy for people to use and cheap, and actually get the desired end result: better sight, so that they can go on and work.

Another particularly good example is this: advertisers have become acutely aware of the problems of "On demand"

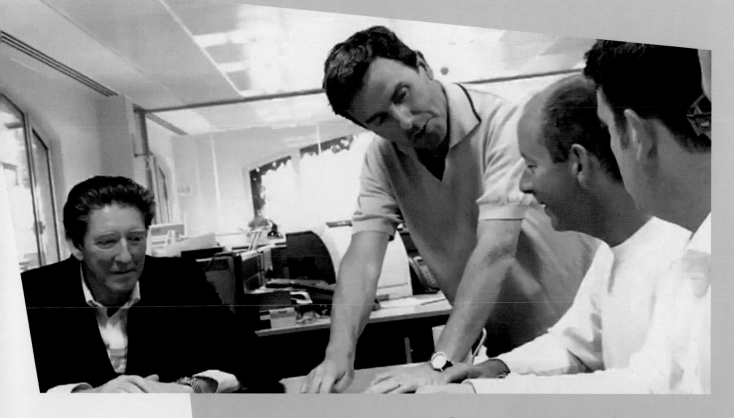

TV, and the ability of viewers to fast-forward through the ad breaks. So Channel 4 in the UK demonstrated predatory thinking to create a new ad format that turns the problems of viewer control into an advantage. When a viewer pauses a program on some of Channel 4's digital channels, an ad is overlaid on the screen until the viewer presses play again. And the first brand to utilize this was Tetley tea—a perfect fit, given that making a cup of tea is one of the prime reasons people pause a program in the UK (although an ad for toilet paper would have worked just as well).

Really, predatory thinking is about trying to change the context, trying to find an advantage, and being inherently competitive. We have a process we go through to help encourage this approach, but really it's just trying to come at things from a completely different angle, to rewrite the rules, putting our client at an advantage over their competition. We find it's really good for challenger brands, trying to muscle their way into a market and steal market share, or for getting people to totally reconsider something and change their behavior.

Changing Agencies

At CST The Gate, we call ourselves an ad agency and yes, we have a rich heritage of producing traditional advertising, but most of our clients want an integrated approach to campaigns. So in-house I have an expanding digital team, a media planning and buying team (unusually), a design studio, an AV division for content creation, a marketing consultancy function, as well as the planning, account management, and creative departments.

Originally, it was the industry norm for media planning and buying to be in the same shop as creative origination. Then the industry changed with the media agencies setting up store as separate agencies, which is still the norm. Increasingly, our best accounts in some respects are where we can take ownership of the whole campaign, because they get all that in one place, thinking in a genuinely 360-degree way about the client's brand and how their customers interact with it. From the client's point of view you think in those terms anyway—you're naturally integrated as a client, so for some people it's very useful to manage all that in one place.

Digital Considerations

There's a great deal of industry talk about consumer engagement and personalization and so forth, much of which has been brought about by social media and the immediacy of digital media. Increasingly, we're putting digital solutions right at the heart of our strategy and delivery. But we never lose sight of the enduring principles of building campaigns for our clients, and the primacy of ideas in relation to actual execution. We work for our clients, and whether it's a charity or it's a business, you're trying to get somebody to do something. If you're trying to build brands over time then yes, you have to think about how ideas flow into these various different touch points, and it's a lot more complicated than it used to be. That creates opportunities to do really lovely creative work as well, but fundamentally it still comes back to what's the idea, what are you trying to do, who are you talking to? The same old questions still absolutely apply and the same truths: that people are still human beings who behave in a certain way and get motivated by certain things.

Absolutely we have to think in a very modern way, but you reconcile that with the fundamental truth that it's still all about an idea—have you got anything interesting to say, why should people believe it, and what do you want them to do?

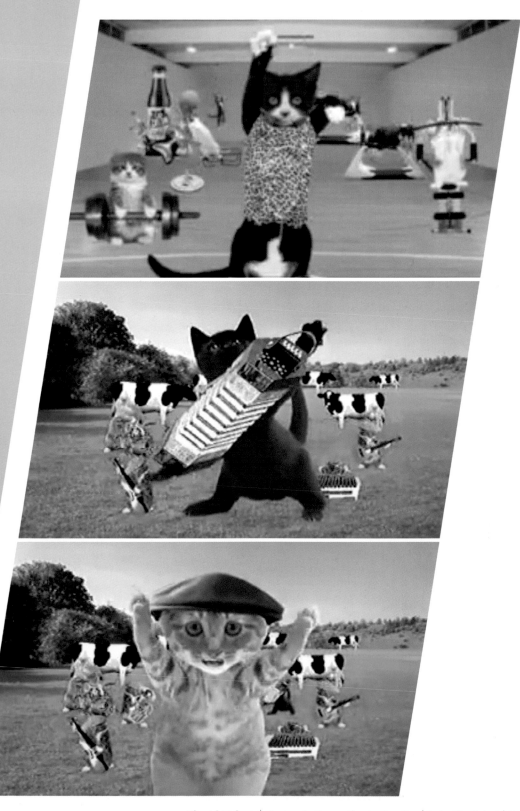

Chapter 2
Preproduction

As with almost any conventional filmmaking, a commercial is born from its script. A commercial script is written in a particular way: it describes what happens, what the action is, what the dialog is, and what the voiceover is.

ALL: Carling "Space"
(Beattie McGuinness Bungay/
Sonny London, d. Fredrik Bond).

Scripting and Storyboarding

Sometimes in an early stage it will look rather like a film or TV script. From there, however, it is broken down into three sections: one column for action, one for voiceover, and one for graphics, since it's easier to picture a finished product as one is reading it.

The "script" from which the commercial is shot is called the "board." This is derived from the process above, and takes the form of a storyboard with actual images representative of individual shots and action, with written description, dialog, voiceover, and so on beneath the relevant frames. This is what is presented to the client, and on which they will either buy off or not.

Sometimes, they take it away and test it; sometimes they will test a couple of scripts to see what people think and gauge the finished commercial's probable chances of success in terms of attracting an audience and conveying and selling the product message. They are spending a lot of money on the commercial, and they want to get it right. Before the production company and the director are brought in, the client and the agency will have narrowed down their options, normally, to up to three scripts that they may want to do.

Development of Vision with Production Company and Director

Within the agency there is a producer with whom the creatives work, and it's the agency producer's job to speak to the reps for production companies, looking for a suitable director. Typically, the reps are aggressive in trying to put their directors forward, and the agency may look at as many as eighty different directors' reels. The producer will vet them extensively, and present the creatives with a shortlist of perhaps ten reels, from which they will narrow the choice down to three directors they really want. Those directors will frequently be unavailable, because they are highly in-demand, successful, and exclusive; because they are busy; or both.

A final shortlist of perhaps three directors is eventually chosen from those who are suitable, interested, and available, and the agency will then have a conference call with each director and his reps. They present their board, talk it through, and describe how they imagine it. The director gives his initial reactions, and then will go away and think about it, research it, come up with ideas, and return with an interpretation of the script, written almost like story and sometimes even incorporating visuals, known as the "treatment." In fact, it is often not the director himself who does this, but a writer he hires for the purpose to put into words his own ideas about the board. As such, there is a great deal of scope for the director to be creative, to flesh out the skeleton of tone and purpose that he has been given. This process of enhancement also continues through the subsequent contributions of the production designer, the cinematographer, the actors, and so on.

The aim is for the board to be transformed into something greater than either the client or the agency had envisaged, but which remains true to the central brief. The agency is looking for someone not merely to execute their board, but someone to enhance it and to use it as a stepping stone to new creative heights. There are no radical changes at this stage, however; for one, the board is what the client has agreed to make, and they've normally tested it for a couple of weeks with their demographic and against other commercials, so they know what they want to say and have a good idea of how it works. Basic things might change—a few words, a location— but nothing truly fundamental.

LEFT: Cadillac Escalade "Tiki Barber" (Modernista!).

Logistics

The next step is for the producers at the agency and the production company, sometimes along with the director, to work out the logistics. More often in recent times, this begins with working out what will be done physically and what will be computer-assisted or entirely generated. An effects or digital post-house will be approached, depending on the nature and extent of the work involved, and asked to bid for the job of creating the physically impossible or impractical. The amount of money that can be spent on visual effects is almost limitless, so there is value in involving the effects house at this stage to work out what they can do in the most cost-efficient way.

Once all of these areas have been covered, examined, and worked out in detail, the key people involved, from agency producer to production department heads, will gather for the preproduction meeting. The plan for the production is laid out, checked, and reassessed, from wardrobe choices to visual reference materials on location, look, and tone. Potential problems or inconsistencies are identified and hopefully ironed out, and all being well the actual shooting of the commercial can now get underway.

LEFT: Heineken
"The Date"
(Weiden+Kennedy
Amsterdam/
Sonny London,
d. Fredrik Bond).

David Lyons: Executive Producer

David Lyons is the founder of Moo Studios, a boutique production company based in Los Angeles, with an in-house studio, model shop, and DFX suite. With a roster of award-winning directors, David has overseen commercial production for companies from xBox to Guinness, Google, and Visa; he has also produced several award-winning short films, including *Solipsist*, directed by Andy Huang, winner of the special jury prize for experimental short at the Sundance Film Festival.

ABOVE: The Economist "The Brain" (Moo, d. Shaun Sewter).

RIGHT: Go RVing "GRV" (Moo, d. Shaun Sewter).

ABOVE RIGHT: Iff "Boston Film Festival" (Moo, d. Adam Byrd).

Out of school, I got a job in the production company Limelight, doing music videos like Dire Straits' "Money for Nothing" and "Sledgehammer." But they also had a commercial wing, and I moved into that. There were probably only fifty people who worked for the company, about twenty-five here in Los Angeles and twenty-five in London. So I came out here and worked for Limelight in L.A. for a month before they went bust, and then I freelanced for a couple of years at commercial production companies as a line producer, and then stopped doing that and set up my own business, Moo Studios, in 1999.

Generally speaking, and of course there are no hard rules, my title 95% of the time is executive producer. I'll work with my sales reps, and then we take the director through the bidding process, and once the job is awarded we celebrate a little bit. We then hire a freelance line producer, and I will introduce them to the ad agency and they'll take over the project. At a higher level the executive producer always keeps in touch with the agency, because you want to make sure everything's running smoothly and that

they're happy. The agency needs somebody they can go and talk to if they're not happy about something, because they don't want to go and talk to the line producer. One hopes that will never happen, but of course often it does. The standard industry workflow for the creation of an advertisement, which is in fact fairly inviolable, starts before I'm involved. The client and the agency have done a lot of work and produced the board, or storyboard of the ad, and there's a comprehensive brief in place. The agency has decided that they have a commercial that is going to be, say, a family sitting at a kitchen table, lifestyle-oriented or whatever it might be. Once all this has been approved, the agency looks for a director and/or production company, and the process enters the stage that I handle.

Getting the Job

My role at this stage is that I represent directors, and I work with the sales reps, trying to book jobs for our directors. There are a couple of things that will make me

want to put a particular director on the books: first, they've already got a track record so we think we'll get work for them and it'll be easy—it's never easy, but that's one thing. The second, and more important, is that they have a voice, something you can look at and think very personally, I get that, I like it. Your hope is that if you see something you really like, somebody else will too, and it's easy to sell if you really believe in somebody and believe in their work. Of course, I'm a realist as well, and if someone comes along and they've got a regular client, then I love them. Whether or not I am actually inspired by them, as executive producer your role is to bring out of the director what you feel is their best performance, their best work, and to try and squash down any ideas they're having that you know the client and the agency are not going to be happy with. You do have a creative role to play from that point of view, but it's more about managing an artist's urges. You're responsible for the creative side in that if it goes wrong, you're going to get an earful.

So the sales reps, hopefully, will hear about a job, and a script, and they'll be putting our work and our directors up for it. Once a script comes in, then I'll speak to the producer at the agency, speak to the director, and we'll have an initial conference call, which is crucial. For us, if the call goes well—and you can tell; for example, if the director can throw some extra ideas in which are received well—you know you're in a good place.

Most production companies—all bar five or six, as far as I can tell—do not have their own stage. We do, and that is because it makes us more competitive. It also means that when we're bidding on jobs we can just run up to the stage and shoot something, and then take it back and put it in the computer and do whatever we're doing to it. It's extremely useful. In addition, any job that my production company handles, we in fact always do all the post-production in-house, and see it through to the finished picture, as opposed to going to another company that charges a lot of money. More companies are starting to pursue this workflow now, but traditionally, in America, the production company's work is done once the footage is captured and handed over to a post house.

Once the initial conference call happens between the agency, the production company, and the director, the director goes off and does a treatment. You maybe

ABOVE LEFT:
Delphic "Doubt"
(Moo, d. Andy Huang).

ABOVE:
Toshiba "Car"
(Moo, d. Andy Huang).

have a follow-up call to explain the treatment; the budget's put in at the same time, and of course you're aggressive on the budget; and the agency then makes a recommendation to the client. They pick their favorite director, and that's important —it's three directors, three different treatments, normally at three different production companies, and once the scripts go in, the agency will ninety-nine percent of the time make a recommendation of who they want to work with, and they'll go to the client and present to them. The agency will do everything they can to get their recommendation awarded the job, but they don't always win. Normally they do, because that's what they've been hired for, essentially, but they don't always. Once the client agrees and gives the go-ahead, usually you're shooting the following week, and you're up to full speed right away.

Preproduction

The financial side is interesting in itself, because the client knows what it wants to spend, and the agency knows what the client wants to spend, and by the time they get to us there's not much left. Hopefully we'll know we've got, say, $300,000 to spend, or $600,000, or whatever it might be. In the UK, the production company's side of the budget will be to cover everything below the line, everything it takes to pay people, to rent equipment, to rent locations—absolutely everything to deliver a tape with the finished commercial on it.

We'll do the casting, but the talent is actually paid for by the agency, primarily because of residuals [payments for repeat broadcasts]. And this can actually affect the logistics of a shoot; it may be very attractive to shoot abroad, for the reason of talent costs in front of the camera. If you hire someone in America, or Canada or other places, you have to pay them their session fee plus residuals, and that can be very expensive. Whereas if you go to Spain, say, the agency will give us the money to pay the local talent, and that's a buy-out. You can do what you want with the ad, with no residuals.

The other person who gets residuals is the composer for the music, but again, the ad agency deals with that: they'll normally ask who we like for music, and we'll tell them, and they'll go along with it if they like it, or not. If the agency wants a name in the ad, or to provide the music, that'll be factored in before it comes to us—they'll already have done a deal with the name. That's a whole other genre in fact, celebrity shooting, and it tends to be that once the director has been selected, the agency then has to get the celebrity to agree to that director. And of course sometimes the director may already have a relationship with the celebrity.

It does happen that you get a commercial on your plate and you think, this is terrible, and you look at it and say, this doesn't work because of that reason. But my job is to try to make it happen all the same. I do have some directors who if they don't like it, they don't want to do it, because it doesn't make sense to them, but frankly they should do it. You're not going to put it on the reel, but you want to do it for the relationship or other such reasons. In a sense it's not really my problem how good or bad the idea is, as long as it's executed to the satisfaction of the agency and the client. The main issues are dealing with people. You know if you're going to hire a particular person, you're going to have to deal with that person. You still want to hire them because of what else they've got, but you've got to manage them. That's the only real difficulty. Everything else follows a logical path: there's very little I can think of where one could say, that's not logical but that's the way it works.

The Shoot

The amount of time dedicated to the shoot—and the whole process—varies hugely depending on the amount of money there is to be spent, but also on what the technique is. If it's a scene in a kitchen, say, and you have the money, then you want to build it on a stage because you can control it. But if you don't have the money, then you have to find a physical location and shoot there for a few days. And sometimes in fact the prices can be similar. Sometimes there's not very much money, and you're doing live action, and you're going to be done by Friday. Other times there's still not very much money, but you're doing animation, and that could take you six weeks. Normally, as a rule, there's never enough money and there's never enough time. It's the usual thing. It's not really different from television and movies. Yes, commercials are smaller and quicker to make, but the amount of money that's spent per second vastly outspends a feature film, which vastly outspends TV. More money is spent on commercials, generally, than anything else.

The executive producer doesn't always go to the set, but usually I do. I always think of it as the executive producer's job to go and smile and crack a few jokes and just be there so everyone feels as though they're being taken care of. The other part is to take them out to dinner afterwards. The line producer's job on set is more involved, very much working between the agency producer and the director. The agency will sit there in the little video village in front of the monitor, and they'll discuss what they're not happy with. The agency producer goes to the line producer and says something like, "Can you get them to act better?" And then the line producer goes to the director. There's always that chain, just to stop too many voices getting in the way. It's pretty firm, the chain—it's rarely broken. So essentially you have three producers on set: the agency producer, the line producer, and the production company's executive producer, for a bit, depending on how much they want to suck up to the agency.

The Rise of the Internet

Internet advertising has certainly changed things, but the thirty-second TV ad is fundamentally not dead. It's alive, and it's kicking, and it's not going anywhere. People have been writing consistently for the last ten years that the industry is collapsing, but no it's not. It's a lie. Watch TV and what do you see? You see ads the whole time. To start with, the consensus was, oh it's for the Internet so we don't have very much money. It took a while to educate companies and agencies that it still costs you. You've still got to hire a crew, and a DP, and a location, and stuff like that. It's still going to cost you. At this point I feel, from what I've noticed, that budgets have leveled out. They're no longer saying, oh it's for the web, this is all we're going to spend, this is what we can do. They're more experienced now.

As a production company, it's changed for us in that probably forty percent of our work will end up not airing on TV, and about half the work we do is for the web; the difference is that you'll make a film or something that you hope can be exploited virally, or even just something for the company's website, and the length of it is arbitrary. But if it's a success, about half the things we do, they say, can you make that into a thirty-second spot, and then that will run on TV. There is no standard length for a commercial on the Internet, but people get bored, so that's what you're up against. On TV, they sell thirty-second spots, and 15s (normally two 15s are put together). In England there are 5s, 10s, 15s, 20s, and 30s, and then everywhere has one-minute also, 60s. Then in the UK you

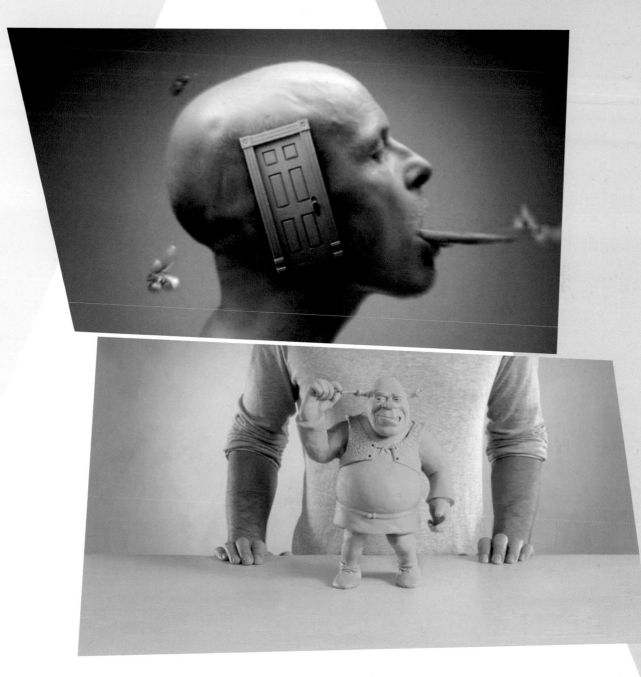

TOP: Moo studios ident.

ABOVE: Xbox "Clay
(Moo, d. Shaun Sewter).

"They're no longer saying, oh it's for the web, this is all we're going to spend . . ."

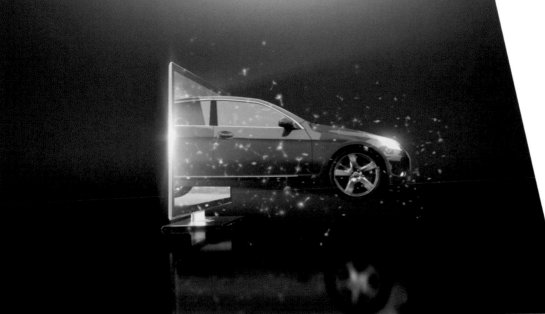

also have 40s and 45s. But here in America it's just 30s and 60s. The other thing in England is that when you make an ad there, you make it thirty seconds, but at sixty seconds you hold the frame for another few seconds; in America you make it exactly thirty seconds so you don't have that ability to hold. It's just the way they do it.

So the rise of the Internet has encouraged people generally to make ads that are longer. They try and do something different. Personally I think it's a mistake, because I get bored. The thing about the Internet is this: when a commercial is for TV, the agency will follow the structure that I mentioned earlier to the letter. It's important. When it's for the web, they know they're not going to have that many eyeballs on it. They'll still have a lot, an awful lot, but they'll target it slightly differently, so it's not quite the same deal. It's still as back and forth as for television, but there's a sense in that while the Internet commercial is important, it's of lesser importance than the TV spots. It's important unto itself, as part of a client's campaign, but the TV ad is usually the major component.

We do banner ads as well as more conventional films. In the early days of banner ads they would hire a company who did Flash, and they could create the banner ad for them. But that was very limited, because the people who actually worked in advertising were not yet up to speed on how to do it at that time. We just did five different films for US Cellular, quite a big cellular company, and we did their banner ads. We made the films, and then they were made into banner ads by a specialized Internet company. That didn't happen before, but now we go to what they call a digital company, or a developer: we give them the footage and they put it together. For us, that's as credible a job as doing a TV commercial, but technically it is a bit different. There are different

considerations of length, and of the actual shape of the image, appropriate to the shape of the banner, and frequently they will be much shorter, only ten seconds or so, so technically we have to do various different things from the TV commercial. Essentially we're doing the same sort of job, but with a slightly different sort of end product, and it's actually more fun for us, because it's a bit of a challenge. They're always trying to do something different, trying to push it further.

There's also another angle with the Internet, where the agency or the original client might say, hey let's go and find the kid who did that glossy/gritty/whatever YouTube clip, and get him to do a spot on our sneakers. It doesn't happen a lot, but it does happen. The main problem—and this is good for us, or someone like me— is when a TV commercial is made they're very precise about it; they want to have this shot this way, it's just so like this, with the option of this and that, the right people in it, the right clothes, the right color of shorts, and so on. Everything is important because it's part of convincing someone that, say, this empty glass is the one to have. When you have some kid making it on YouTube, they don't care about that; they're more about, hey look what we can do, we can smash this, or whatever. So there are occasionally times where it makes sense to go that route, but it's a one-off because it suits what the agency is trying to do. Doritos have this competition that's gone on a couple of years, inviting the public to submit commercials for their Super Bowl slot, and they've made that into something. That's the only case I know where they've really pursued that. A few years ago people wanted to make it look like it was done on YouTube, and they'd spend all this money to make it look like that. But people are not doing that anymore; they've grown out of it.

Fredrik Bond: Director

Fredrik Bond is one of the foremost directors of advertisements in the world today. He has won numerous Cannes Lions, Clios, and other industry awards for advertisements such as Smirnoff's "Love," McDonald's "Baby," and JCPenney's "Aviator," and he has been recognized as outstanding by the Director's Guild of America on multiple occasions. He has just completed his first feature film, *The Necessary Death of Charlie Countryman.*

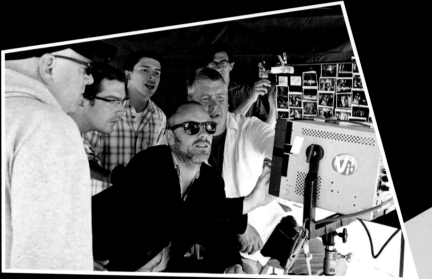

Starting Out

I was actually obsessed with commercials as a kid. I grew up in Stockholm, Sweden, and we didn't have any commercials on television until the mid-eighties or so. At cinemas you could watch commercials, but you had to be there fifteen minutes before the show started and see commercials there. That was the only medium where you could see them. But I always loved them.

We used to spend a lot of time in England when I was a kid, with family friends, for Christmases and summer breaks, and during those stays in England I spent most of my time recording the commercial breaks on VHS. I had this

library of films that I was collecting. My dad had editing equipment, and I was copying films in the basement of my home. I rented movies and copied them and built up a huge library of films. And in this library of films were also commercials from England. Basically, I had hundreds of commercials from British television that I then edited, and made my own little short films with. I never used Super8 and stuff like that, but I took other material and cut together my own short films, mostly through these commercials. So quite early on I really studied them thoroughly, and to me they weren't really like commercials, they were like amazing little short films. It really became more or less my school of how to make shorts. I started doing a lot

of editing and that was where I sort of found my craft. I started editing for a few directors and became something like their creative assistant, talking ideas, helping with storyboards, and stuff like that. There was one great Swedish director whom I was working with who asked me if I wanted to co-direct a longer commercial with him that was going to be used in-house for Levi's—a five-minute piece on this campaign being made by David Sims, the stills photographer. So we were following David for a couple of weeks in London as he was making this Levi's campaign, and that became my first sort-of commercial that I directed. That was my start as a career as a director. I was trying to get other jobs and I thought it was going to launch me into making commercials on my own, but because I had co-directed it with a very famous Swedish director, nobody would give me a job ("What did you do on this one?"). So after a few meetings I had to scratch out his name, and then I landed my first gig.

Ideas

What I'm given by the agency depends. Sometimes they have two written lines, and you have to add everything in there, and sometimes they have the full story laid out, with storyboards and so on, and it's really been sold in very thoroughly so there's not much wiggle room. It's everything from two lines to that. If it's a great story, I just want the credit for the story being great. I don't mind either way—it's really fun to have free hands, but it's also great to have a great story, and you can just make that the best you possibly can.

There are two approaches in advertising. One is to just make it feel like a feature film, which is quite fun; a lot of times the idea is not that sharp, and it's more the execution. Then at the other end of the spectrum is the idea—if the idea is

crystal clear, when the logo comes up and when the pay-off comes up, it's like, wow, what a fantastic idea. I love them both. Preferably when the two meet, it's great— when there's a great pay-off and idea, and you can also make some incredible filmic journey. That's really what I love.

Working

I've never enjoyed going from one commercial to another and having them overlap. I like to spend time with each one, so I haven't actually made that many. I've had years where I've been the happiest creatively, where I've only done like four or five commercials. I've had some productive years where I've done quite a few, but I've definitely never been going from one to another and overlapping and shooting them out. On average they take a couple of months, but I prefer to spend as long as I can on them. The job becomes much less enjoyable when you're under a complete gun, so the more time you can spend with creatives and with your heads of department, and prep it, it's actually a more enjoyable process. It doesn't always happen like that, but it's definitely a more enjoyable process for me.

I definitely like to work with people that I know, if I can, if they're available. There are a lot of advantages and shortcuts if they know your tastes. But it's also exciting to find somebody new to collaborate with. It goes a little bit in cycles. In commercials, especially since I don't shoot one after another after another, I can't keep everybody busy the whole time, so people start to get in the loop with other directors and so on. But if I can, I work with people I know.

Commercials are primarily a visual medium. The performances are important, yes, but there's always just a certain amount you can do, in terms of spending your time on that. I spend a lot of time casting. That's one of the things I love

doing, and I love to find somebody that I really connect with acting-wise, so I do try to spend a lot of time with the actors. But on a commercial there's just so much you can talk to an actor before they think you're stupid—you're just making a commercial, you're not making a feature film, and the actors start to want you to leave them alone. So that's why you tend to spend a long time with the production designer and DP. But I probably spend more time with casting and acting and let my heads of department help with those other elements, like the production design and cinematography. But as a commercial director you spend a lot of time with that, otherwise you climb up the walls. I think because I'm coming from editing, my heart is always sitting in the dark room with one person and together really massaging the film. I love the editing process. There's not much scope for changing the commercial at that stage, but when you're in the edit room and it's clear, you think, wow, we should do this—and it makes it so much better—then clients and agencies are very open to that. Especially now in this climate when they really have to cut through with advertising that's entertaining and feels like it really connects with people, I think they're more prone to saying, okay, we thought it was going to be like this but now it's up here, we see that it connects with you so much better. I think it has become a little bit more open for that to happen. It's partly to do with the fact there's so many platforms now—you've got to cut through the clutter.

Multiple Platforms

There's a little bit of a problem with this as well. They spend a lot of money on one thing that then has to go on a lot of different platforms, for different demographics, different countries, and so it dilutes a little bit. It has to fit so many different aspects

of a crowd, different channels, and so on. Sometimes we do have to shoot a few alternatives to certain scenes, but then the agency will take care of making the different versions for different markets. Most of the time, I finish one version and they take care of the augmentation for the other markets. But I think the better, sharper advertising is much more specific to one country, one platform. Then they don't want to spend as much money of course. But it tends to be more about the idea and about a really cleverly written script.

It definitely can work. The Axe Body Spray commercial I did was an episodic one. I think they aired five episodes, or something like that, and then they had the long version for the Internet and you could go into different alternative endings, or wherever you wanted to go. It was one of those where you could be interactively involved. There's a few of those kinds of campaigns now—Doritos have done one— that are specifically designed for the Internet. But there's also a great thrill to making those kickass thirty-second spots. The tricky thing with the long ones is that you still can't really get into the character, you can't really develop the story like you can on a feature film, so it's a little bit in-between. That's the tricky thing with a lot of short films in general, that you don't get enough time to get to know the character and the story and stuff like that. I really like the thirty, sixty, and ninety second and two-minute formats.

Multiple approaches

I think there are three different categories of advertising. There's the Parisian advertising, which is very poetic and ethereal, and doesn't need to make sense. It's all from the heart and from the gut and emotional, which is really fun. Then there's the London one, which has a little bit more wit, but can allow itself to be poetic sometimes.

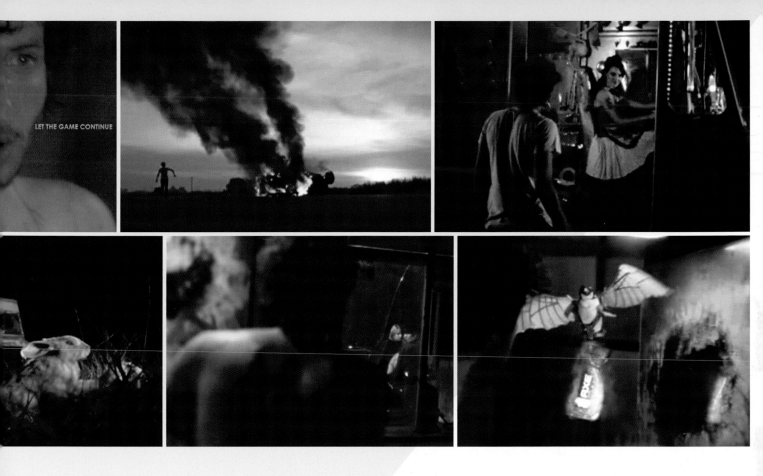

LET THE GAME CONTINUE

And then there's the American one, which really wants to be specific, much sharper in terms of a message and in terms of selling. The American advertising allows for less poetry. It has to be more crystal clear for such a big demographic—east coast, west coast, and middle America. It has to be crystal clear for so many people that it cannot allow itself to be dubious. For me, at least, those are the three sort of genres, and I'm always surprised when something like the JCPenney ad ["Aviator"], which would be very natural in Paris, turns up in America. Those kinds of films are rare in America. Likewise the really sharp advertising that's crystal clear in its concept is very rare in Paris. It's quite fun, actually, when those differences turn up in different markets.

It's rare that the client wants to take a gamble like that, but there are definitely projects where they want to take the more entertaining route, making sure that they get people into a feeling and an atmosphere and a vibe, as opposed to bombarding you with their message or their clothes or their product. With JCPenney, they wanted to blend their clothes into the story, so that by the end of the spot you should feel that you like the clothes—you're getting tricked into liking it as opposed to them bombarding you. It was quite a long ad (two minutes), and there was one shorter version that was a ninety or sixty seconds. There was a string of ads done for that campaign where they really wanted to take risks and be bold.

Ads and Features

The biggest difference for me, between ads and features, is really how much time I get to spend with the actors and figure out the story from their point of view, and craft it from their perspective, which I love. It's very time-consuming, because you talk a lot and spend a lot of time together, but it's ultimately very satisfying. The other difference—a big surprise, actually—is the stress level. The feature I made was low-budget, independent—we didn't have much money so we were really choking on time. But funnily enough I think it's much more stressful on a commercial, even if you have more money, as there's just so much more you need to accomplish in a shorter time. Also because you're relying on visuals rather than only the performances, and to make an incredible visual you have to spend much more time. In the features you can get away with more if the actors are great—I was lucky to have great actors. Even if you have so many scenes to do, and you look at the script and think, how the hell are we going to make these in the short amount of time, the thirty-three or thirty-four days that we have, it went like a breeze, a real joy. There are a lot of other pressures, of course, but in terms of

making the day, we hardly did any overtime. Thanks to a very good assistant director (AD) I must say, who had everything planned. It's a whole house of cards of puzzling things out, how to do things. He was an amazing AD—a commercials AD in fact.

I'd love to do another feature. Both movies and commercials are my first love. If I can have a life with both of them, that would be ideal. I just want to work with great people and great stories and great ideas. The projects become like little families, the thing you're filming becomes like your baby, and the people you work with become really good buddies and friends. I just want to do as good work as I possibly can and be excited for as long as I can. There's no goal agenda with it. I still want to be excited to put the thing on and show my best friend, make people laugh or cry, or whatever. That's the big kick really.

ABOVE: JCPenney "Aviator" (Saatchi & Saatchi/MJZ, d. Fredrik Bond).

OPPOSITE: Heineken "Entrance" (Weiden+ Kennedy Amsterdam/ Sonny London, d. Fredrik Bond).

" . . . to put the thing on and make people laugh or cry. That's the big kick."

Today's the day to believe.

I can't really draw, but I do my own stick figures a lot of times. I actually prefer if that can be the working board, because sometimes with a storyboard you put too many things in there and you get locked into it, but you start to find things that are way better when you start to really place things together. Sometimes they don't even want a storyboard, which I think is great. It's different for different types of stories. Some ads really need a storyboard, to make it really clear for everyone what's going to happen, including for myself, but others really want to have the air. Like for the Heineken ad ["The Entrance"], we never produced a single frame of storyboard. It was all done in rehearsals and in crafting it. It was very important for the creatives and me that it became something very fresh and new and unique. They gave us the opportunity—Heineken was very generous and trusting there—to let us make it the best it can be and work out how to do that. So I said, let's stay away from storyboarding, let's just work

around this character we've found and see how far we can push him, and what we can do. So it was going to be a very elaborate process, and that turned out great in the relationship and in the result too. We had a great time, time to develop it each step of the way, just make it a little bit better, and a little bit better . . . oh no actually, that doesn't work, let's abandon that idea, let's go back and so on. When you have a storyboard, it's gone through the head client, the head head client, the head head head client, so then you have to unravel all that to be able to change something, and that doesn't always happen. It's very hard to do that. It was a very exciting project. I tend to think some things can become a little stale with a storyboard. As a director, I think, how do we embrace something that we hadn't expected? Because those unexpected moments make it come alive.

John Ebden: Production Designer

John Ebden is an award-winning production designer for many of the UK's most captivating commercials, including a number directed by Daniel Kleinman. He has also designed movies from *Waking Ned* to several directed by Aki Kaurismaki, as well as multiple episodes of TV's *Comic Strip Presents*. Alongside his designs for commercials, Ebden's company Rug360° is pioneering new methods of creating and interacting with virtual, real-world environments, recorded photographically or designed from scratch.

> "When you get offered something you haven't done before, you have to learn on your feet."

Starting Out

I went to art school. After that I was painting, and broke, and I met some people who were doing rock videos. I'd never thought of design for film at all, but I went along to a shoot, and I thought it was fun. I started working with a company called Limelight, who had an office in Los Angeles as well as London, and moved into assisting other designers, on films and all sorts of projects. From there I started designing films myself, and then I started doing commercials. Art school, then pop promos—that was my path into the business.

There is something like an apprenticeship. It used to be more formal, but it's still there, where you work as an assistant, an assistant art director, an art director. Some people start in the set decoration department. Very few people just steam in and start designing; you have a period of time when you work for other people, other designers first, and hopefully learn. That's what I did, and most of my contemporaries have all gone through that process. I worked with an assortment of people: John Beard and a chap called Peter Hampton who used to work with Ridley Scott. I worked with quite a few different people—I never really gravitated to one designer. Because of the pop promo, you tended to be asked to do it quite quickly. After a year or so they'd say, you can do

ABOVE: Tennent's "New Firm" (Newhaven/Rattling Stick, d. Daniel Kleinman; production design by John Edben).

that John, and you'd reply, yeah, sure—because it was quite a simple project; it's not like someone's asking you to design a movie—and then you'd go off and panic. When people were just in movies there was more of a hierarchy and it took a lot longer, but things like pop videos opened it up for people to get on quite quickly. Then one day a director who's doing rock videos might get offered a commercial and say, well do you want to do a commercial with me? I remember that. I remember working on rock videos with a director and then he started doing commercials and I started doing commercials. It was quite rapid really. Maybe too rapid. But when you get offered something you haven't done before, you respond, and you have to learn on your feet. I'd worked with these other people, and learned a lot from them, and you definitely need to go through that process. In London, music videos used to be quite an industry, out on location, in the studio, with an art department, and costume, and all done in camera. Now I think if they are being made at all, it's usually in front of blue screen, with computer graphics and all of that. But when I first started it was quite prolific: there were Queen videos, and Madonna, David Bowie, and AC/DC. They'd be huge productions, with companies in London and L.A. just making their fortunes out of making them. But not any more.

Preproduction

What I get given when I'm brought in on a commercial tends to vary. There'll be a storyboard somewhere in the process, and obviously you've got a script; then the director will do a treatment, half a dozen pages long, through which he's trying to sell his ideas to the agency, who then try to sell it to the client. Within that document there'll be visual references, and usually you get a clue of what the director wants, and then obviously the script, which comes from the agency, will also contain design references. The director will put together the storyboard, but normally they're very loose—they don't actually contain specifics—and at the same time as the storyboard's being done, the designer will be doing drawings, visualizations, of proposed sets or locations.

In these earlier stages you tend to go out on limb, coming up with things. Based on conversations and meetings you just design something, and then it goes back to everybody and they either like it or they don't, or they might want some changes. It goes backwards and forwards. I think everybody feels very happy just to start the visualization process. Because there are so many people involved, and obviously so many of them don't really know what they want, or haven't made up their mind what they want, the visualizations and drawings help everybody focus, I think. It tends to be that, rather than being very specific at an early stage; they rather like the designer to go off and come up with ideas that can then be accepted or rejected. Sometimes pencil drawings are just fine, and we sometimes take a pencil drawing and color it; or we go 3D and do something on 3ds Max or one of those drawing packages. It all depends on how much time there is, and then of course the subject— sometimes a pencil drawing can say it all, rather than getting involved in time-consuming 3D work. Also 3D tends to be very clear, and very stark, and almost too specific. If you come up with a visual that's too photographic, it tends to be used

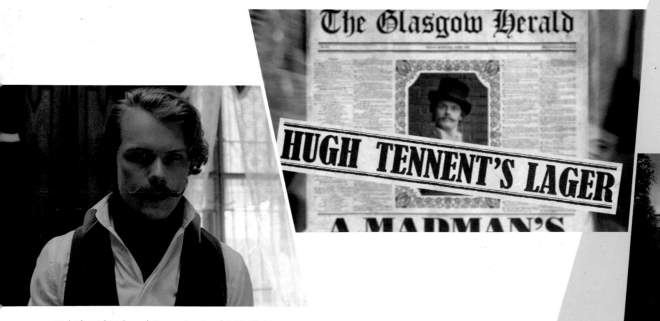

right the way down the line—somebody'll say, well in the visual there was a blue car, or a blue chair, and where's the blue chair gone now? To which you say, no no no, that was just the visual. You have to come up with something which informs, but which is not too specific, because there are a lot of people involved in the process and they can hold you to it—a month after you've done a drawing they'll say, this doesn't look like the drawing you did. The drawing was just a concept, but if it's a very photographic concept, like 3D, it can get you into that kind of trouble. You have to make a choice depending on what the subject matter is, but you do basically draw everything. The Tennent's job I did [three separate ads based on Scottish brewer Hugh Tennent: "Madman's Dream," "Can Monkeys," and "The New Firm"] was a lovely one that involved a lot of design. It was done in the Czech Republic, and the clients were great, and the agency was great, and I had a lot of fun doing that. First we did a scout, me and the director [Daniel Kleinman] and the producer [Johnny Frankel], and we

found a world that the ad could inhabit, with a castle and the grounds and so on. From that scout, we then started drawing and designing sets and models. We drew everything on that: there are little models of the carriages, the boat, the big trunk that the hero comes out of with the monkeys. All that was drawn—there's a book of drawings on an ad like that. It was a big production, but it still only took a couple of months from start to finish: not just shooting, but the scouting and preproduction, as well. A smaller ad might take only three weeks, on the other hand. I could get a call today and it could all be over in two and a half weeks' time if it's a simple build. I've just done some work for Intel at Pinewood Studios and that took two months, with about a dozen people in the art department and forty in construction; but the next job's British Airways and that's two and a half weeks' work. They vary a lot.

BELOW: Tennent's "Madman's Dream" (Newhaven/Rattling Stick, d. Daniel Kleinman; production design by John Edben).

Types of Design

I like the period ads. They're always great for the art department, like the Hovis bread commercial and the Tennent's, and there's other stuff. We're just about to do something that's like a remake of an Audrey Hepburn film. That'll be 1960s. I like building sets in studios. All designers do. It's what we're best at, and we like doing it.

There are also projects that require a look. It's not just filming on location or in a studio in a representational way. Something like the Specsavers eye glasses one where you can put a slant on it—you can use unusual cars or colors. You can give it a look. That's always good. If you're just filming a high street, or an exterior or an interior as it is, it can be great. But when you're giving it a look, when you're imposing some kind of language on it, it's always very satisfying. I tend toward realism in design. Some designers have a more theatrical base, and I've never really done anything like that. I like doing some period stuff, but generally speaking there are other people who are very theater-based and do stage-type things. Sometimes you get a project where you think, I'm not going to be good at this, I think I should turn this down. There was a job recently for Bailey's and they wanted this huge dance project built, like Busby Berkeley, and I just knew it wasn't for me. I didn't take it on because I knew I'd be struggling, and I knew exactly who was good for it, and by God he got it. There are certain things like shiny dance floors and Fred Astaire routines that I know are just not my thing. I'm better at a certain realism, I guess. You just know instinctively after twenty years that the shiny dance floors and big curving staircases with a Fred Astaire lookalike—it's just not going to happen for me. You get a feel for it.

ABOVE LEFT & ABOVE: Specsavers "Eerie" (Specsavers in-house/ Rattling Stick, d. Daniel Kleinman; production design by John Edben).

Design and Effects

The big change since I started out is the amount of work that the post-production people are doing. Obviously people are writing ideas that they know can be pulled off because the sky's the limit now; they can do anything they like. Years ago it was ridiculously expensive or impossible, so you didn't come up with those ideas. One we did for the [2012] Olympics, with a British Airways plane driving along London streets—that concept would have been impossible and you wouldn't even have attempted it. Now it's just shooting planes for post-production houses like Framestore or The Mill, and they drop them in. In film and in commercials the post houses have become very powerful.

It's still a separate area, however, and they very rarely get involved with design. They will let you know how they want things shot and what they require, and they'll have somebody on the set making notes, telling the cameraman what sort of lighting would be best and what needs to be shot, but they don't really come up with the ideas so much. Sometimes you come up with something and they say, yeah, we can't do that. Or rather it'll be the amount of work, and so the amount of money it would cost to realize the idea successfully—then it'll get stopped at an early stage. The Mill or Framestore will put in a budget that'll just be astronomical, or the amount of time it'd take to carry an idea out will be beyond the schedule that the client's got. They'll want an ad on air in mid-August and the effects people might say, well we've got three months' work on this, working night and day. So they can't do it. It's very post-oriented now. For instance, one British Airways ad was creating a modern airliner, a passenger plane. Every frame of the commercial had a BA plane in it and that was all CG. That was a lot of work for them, and probably even four or five years ago it would have

been impossible. Software and computing power are changing so fast that things that maybe only two years ago were impossible are now possible. The good directors, though, are aware that an ad full of special effects, as per a movie, isn't necessarily always a good ad. I think people are getting very leery of special effects, and of special effects looking fake. It's still down to great ideas and a good concept, and a good director will know how to keep the post in check so they won't go off at a tangent and produce something that's ugly to look at.

Rug 360°

360° is an offshoot of the design work I do on commercials. It's work for architects, primarily, computer-generated visualization. Some guys who work with me came up with a way of building interiors and an interactive walkthrough, so that you can go on a journey through an apartment or a building, and you can look up or look down—just look around really—interacting with a concept that's yet to be built. And this obviously can have a use in the commercial business as a pre-visualization tool.

People like CG houses are doing this stuff for commercials all the time, but it's not interactive. It's a different software, really: computer-generated animations, or computer-generated themes. It could be behind an actor, or it could be the whole thing. There are a few interactive shorts I've seen. There was one made for Land Rover ["Being Henry"] where a guy was going for a walk down the street, and he was interacting with his environment. He got into his Range Rover and went for a drive, and you could choose what he'd do. It was pretty good. There is a future for interactive advertising, where people go online and interact within an environment, making choices about a product, changing its color, going for a walk in it. You already do that with restaurants and hotels.

ABOVE: British Airways (BBH/Kleinman productions, d. Daniel Kleinman; production design by John Edben).

Normally it's with somewhere that's been built photographically, but some of our interactive projects are yet-to-be-built—they're all built from CAD projects. It's just a bit expensive to do it at the moment as it requires a lot of rendering and all that.

Commercials and Movies

Mainly because of other business interests, I haven't been working in films for a while, because it always involves going away, and I've needed to be in the UK. Films also tend to be a long commitment. I don't know where the time has gone—I was only going to take a couple of years out of film, and it's probably been about six now. I haven't done a rock video for a long, long time; I've been concentrating on commercials.

Working on commercials, length and time commitment aside, is somewhat different from working on a feature. On a film, it's very much about the director and the producer, and that's it. You're employed to work directly with a director, and as a designer you would have a much more open brief, and if you've got a good relationship with the director then it's just you two, really, along with costume, and the cameraman. The initial design of the film comes from the director and his designer, and then the producer just kicks your ass if you go over budget. On a commercial, on the other hand, it varies. The agency may just be open to ideas, and wants the director and designer to come up with things; or it can be an agency that's much more hands-on; but there's just a lot more people involved in the design process on a commercial, and then it's got to be passed through the client. You come up with an idea: the director's got to like it; then the agency have got to like it; and then the agency's client have got to like it. Whereas on a movie it's more direct—the only person who's got to like it is the director. Advertising is a business, and the client is part of the process because obviously they're footing the bill. So there's a hell of a lot of people to satisfy, and it can get a bit silly at times.

The Director's Vision

Working with Aki Kaurismaki was all a bit crazy, but I wouldn't have missed those years. I worked with him for three or four years, I think. He liked the film to be like a painting, you know, colors. And it didn't relate to any world—it could have been 1950s, it could have been 2010. It was a Kaurismaki world. You're never quite sure what period these films are in, but they're visually quite sumptuous. Aki was very much into design and colors. It was good.

The thing is, with some directors, they have a vision, and then they can transfer that vision over to their crew, and that's what he had. He had such a distinctive, individual language, and he had the ability to convey that to the cameraman and the designer; once you're in his world then you're off and running. A lot of directors don't have that ability. Or, a lot of really good directors are more interested in writing and dialog and actors, and they expect their heads of departments to do the other bits. They accept that they're not visual people, they're writers, they love dialog and performance, and they employ cameramen and designers to create a world for them. Whereas with someone like Aki it's just, I want that blue. Yes, Aki. I want that red. Yes, alright. Then after a while you're in his world, and you understand his language. This holds true for commercial directors as well, although in commercials there are a lot more visual directors, as they tend to come out of agencies, or they might be photographers. But it does apply to both worlds. For the designer, at the end of the day, it's all the same thing—you have to design a set, visualize it, present it, and then get it built. That doesn't change.

OPPOSITE: Mercedes Benz "Falling in Love Again" (Merkley + Partners/ HIS Productions, d. Gerard de Thame; production design by John Edben).

There's always a bit of an issue in advertising, which doesn't crop up in film. If you're making a film set in the 1950s, obviously it's got to be the 1950s. But often with advertising they want to give it a little flavor of something else, not just recording a modern-day scene. They want to give it some kind of look. There was a successful Specsavers ad I did, to which they wanted to give a slightly retro, David Lynch feel. But it's dangerous territory, because if you start sticking period props in commercials and you start working within that world, it can cause clients quite a lot of concern. They'll say, we're trying to sell a product in 2012 and this ad looks like it was made in 1970, that's no good to me; I want people to think my product is new and relevant to the now. It is a really tricky area, and it's quite often difficult for the agency to push that period thing or, like the Specsavers ones, the slightly surreal, or unreal thing through. Clients ultimately want to sell their product today. The thing with Specsavers—and I've designed a number of them—is that they have a history of quite odd surreal ads, and they're known for it. That's their thing. They've set up this strange sort of genre that they seem to be happy with, and they stick to it. If your eyes are doing strange things, then you should be wearing glasses.

An interesting one I did a while ago was for Mercedes, where it all looks like period footage, but much of the ad was scenes we recreated. It was a bit ground-breaking, really, the way it was done. It was a mixture, and that was just great, because Mercedes cars have a great history, and probably three-quarters of those cars were shot in camera—the actual car. We built a scene around each car, so they brought over a Gullwing 1950s racer, a big old racer from the 1920s that we shot roaring down a dirt road, and a load of others. It was quite a dream job.

Chris Harrison: Agency Producer

RIGHT: Filming "Spaceman" for Carling in New Zealand.

As a production manager and producer for Rattling Stick, Chris has been involved with numerous high-profile advertisements of recent years. He has worked with some of the world's top directors on spots ranging from Carlsberg's "Everest" to the acclaimed "Three Little Pigs" for the *Guardian* newspaper.

Becoming a Producer

As is the case with the majority of people I know in advertising production, I started as a runner—at the bottom, making tea and coffee, running errands, and so on. Then I worked my way up to assisting, then production managing, and then producing. It's quite a democratic process. This is one of the few industries left where there is an old-school apprenticeship where you walk in and start at the bottom, and hopefully ten, twenty years later you're at the top.

Being a production manager is more about the nuts and bolts and making things happen: if someone needs something you book it, speak to this person, get it there at a certain time, make sure it's right. It's very organizational—there's a structure to what you're doing. Being a producer is more political. As a producer you're dealing with the agency and the director and overseeing the budget. That can sometimes be harder than trying to find an obscure piece of equipment or finding a member of crew.

The point at which I'm brought in varies. On "Three Little Pigs," for example, the agency had the idea and the script they'd shown to the client, but it wasn't a signed-off script. Then Ringan [Ledwidge] came on board and he came up with his own vision and idea for his treatment. They then presented that to the client with Ringan on board, and that helped the client sign off on the whole project. But there are other scenarios, like a job I'm working on at the moment, which has been through four years of testing and had something like six scripts rejected by the client, and they've spent hundreds of thousands of dollars on research and animatics and tests. So by the time it comes to us it's pretty locked in, the idea of what the client wants—this is what research have brought in and this is what we're going to make. There's not much room for variation or creativity when that happens. But on other jobs, thankfully, the director's brought on board with an idea, and he's there to make that idea better.

Being a Producer

The final approval process on a film is with the producer, but on a commercial it's with the client, who's ultimately paying for it. The director will have his edit and the agency will take that on board and, hopefully, go with it (but not always), and they then present it to the client. At the end of the day it's the client who's paying the bills, and they know their market and have done their research, and they know what their consumer base is after. Obviously the client comes at it from a business point of view and the director comes at it from a creative point of view, and the producer has to position himself somewhere in the middle; his role is to help the director to realize his vision and idea, while still taking on board the politics of the agency and the client and their demands.

Preproduction

By the time you turn up on the shoot, everyone should be aware of what you're doing and how you want to do it. Obviously you still have the element of the creative on set, or putting the camera in a different position to how you'd originally storyboarded it. Especially if you're shooting comedy, there might be a quick one-liner that wasn't in the script but works really well. There's still always the freedom. But I think the days of a client seeing an edit for the first time and being shocked or amazed are long gone. The week before you shoot you always have a preproduction meeting where you go through everything: the cast, the wardrobe, the locations, the props . . . everything. So there's very little left to chance.

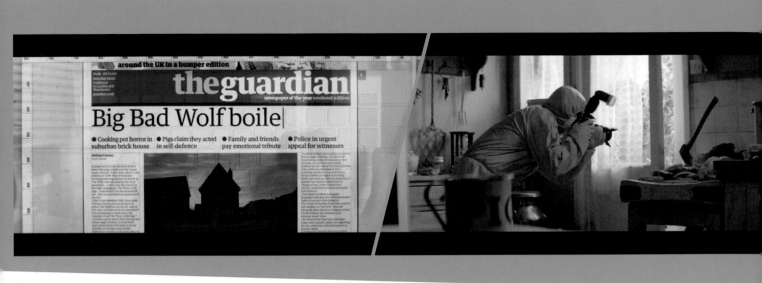

In terms of the cast themselves, the agency and the client will work out the casting brief, and the director will be in on it as well. A lot of the time you'll be using the same casting directors as have worked on big films. It's the same thing for them as anyone else—they might do a big film, but you take on a commercial and you can turn it around a lot quicker. Everyone's happy to do commercials. I don't think there's a massive dividing line between features and commercials. A lot of the time it's the same crew. The choices you make in preproduction, such as location or studio, are always down to the individual spot. One thing about commercials is that because our shoots are two, three, five days long, it's very rare for us to make huge elaborate sets. For a feature film, you might build a whole underground railway station, for example, whereas we'd just go to the real station. Films obviously have bigger budgets and longer schedules so they can have a three to four-week build, shoot for two weeks, and then have a week to strike the set; we have to be in and out in a week or so. We do build sets, but we tend to do a lot more on location. The length of the preproduction process genuinely varies depending on the project—no two jobs are ever the same. If there's a script that's to shoot in a three-bedroom house in London with a family of four, you can probably turn that around in two to three weeks fairly easily. But some of the bigger productions of course require much more lead time and prep time. The job I'm working on at the moment is requiring quite a bit of prep time for the post-production. That's quite unusual actually, but in this case the post-production actually needs to create stuff before we shoot in order for it to work after we've shot it.

Post in Pre

In the olden days, years ago, post was exactly that. You'd shoot the commercial on film, do your edit, and then hand it over and they'd finish it. Now, partly because schedules are tighter, and partly because the technology's so much more elaborate and complicated, quite often you'll meet with the post guys before you even shoot anything. Sometimes they're one of the first people you call—how are we going to do this? I've never actually had them say, we can't do that. I've had them say, we

can't do that in the time, or for the money. But I think you can kind of do anything. Although that doesn't mean you can do everything well. I think when people write scripts obviously they know the limitations of what the technology can do. Quite often the post-production guys exceed their expectations. You think that something's not possible and they say, well there's this bit of technology that we're just developing . . .

For example, crowd replication years ago used to be done with a hundred people in a square, and then you tile them and move them around in blocks of a hundred. You'd see a shot of a football stadium and you could kind of see the joins that moved in waves. Whereas now, a football stadium will look more realistic—they'll actually make individual people to put into the stadium, rather than the blocks of a hundred. What they can do now is fascinating. There's always a way. Quite often we'll have a post-production supervisor on set with us, who'll advise on how to do something. Which actually makes his life easier after the job, if he knows what happened on the shoot, and he'll advise you on how to shoot it in order to make it work. That's a key thing. It's all about dialog and cooperation and collaboration—everybody talking about how to do something makes it much easier to get it done than asking them after the event how to fix it.

Post-Production

I remain very involved in post-production, because a lot of the time you're organizing, being the link between the agency, the post-production, the editor, and the director; you make sure the director gets where he's meant to be at any given time, and comments or feeds back on anything he's been sent. It's very rare that anyone would send anything direct to the director; you send it to production and then they'll send it out to the relative parties. So as long as the director's involved, the producer's involved, and a lot of directors want to be involved to the very end.

That's the British set-up. In the States it's different, because the agencies kind of control the edit. You shoot it and they take the rushes and three months later you see the finished version, whereas over here it's a lot more involved. The director will be there on the final day in the sound studio,

with the sound man and the agency. Nearly always you'll be prepping one job while another one's in post. That's if you're busy. Otherwise you'd only get to shoot five jobs a year. You can't really talk about an average year. As a production manager I would tend to jump from job to job a bit quicker than as a producer. Now it may be around eight a year—sometimes you'll do one a month, and then you'll do one for three months. Or you might have six weeks' prep and then some post. So over the course of a year, probably eight to ten. But I did twelve a couple of years ago.

Problems

There are always problems, but I've yet to come across a problem that we haven't managed to work around. There don't tend to be recurring problems, because if there are you've got to ask yourself why you didn't spot it the second or third time around. But there are always minor issues—struggling with locations, struggling with casting, struggling with this, with that. Ninety-nine percent of the time you just do it, and it all works out, and you all laugh about it in the bar at the end of the job.

I did one recently, which was the first time ever where the location blew out two weeks before we shot, and that'd never happened to me before. In the end, you manage to find another location and make it work, and everyone's happy with it, but that was quite worrying—the location's gone, boom. It's just part of the job—finding problems and coming up with solutions.

Commercials in a Changing Climate

As a company, we tend to work on traditional TV and cinema advertising. But there are other companies out there who'll do more interactive web, or viral, or digital stuff, and you do see some interesting ideas, like overt linking of a TV ad with a viral campaign, and then with a billboard campaign. There's interesting developments out there.

A few years ago viral was the new buzzword, then digital was the new buzzword, then content was the new buzzword. But you go to Cannes in the summer, and all anyone's talking about is the main film category. If anything, in today's market, I think there's even more need to do a big advert. You have kids sitting at home and they're on Facebook, they're on Twitter, or they're watching the TiVo. The opportunities to have the whole family around watching something are far fewer than they used to be. You've got less opportunity to reach a wide audience, so when you do have big TV moments—be it the Super Bowl or the X Factor Final—there's only going to be so many adverts in that commercial break during that TV show, so you want to be remembered. Agencies will make a note of the number of Google results for a certain phrase before and after the advert airs, and you can watch it spike if its popularity rules. One way to judge is if people are retweeting stuff, or talking about stuff. You can get an instant response to your work. We had a commercial air during the Sunday night results show of X Factor, and an hour afterwards we went on Twitter and put in the keywords and there's thousands of people talking about this advert. Obviously that can be very satisfying. I've been lucky in that I've avoided jobs that I don't really want to do. One of the benefits of the relatively small size of the company is that the directors don't really have to take on a job they don't want to do. And I think you get more out of the project that way. It can still be a tough job, and it's easy to lose some perspective. But I did one I didn't want to do a couple of years ago, and I was invited to dinner and my friend's wife said, you know which ad I love? And it was that one.

It was her favorite commercial. You forget, when you get caught up in advertising— you can become very cynical and miserable, but people do actually talk about them, and enjoy them, and have their favorites.

The "Three Little Pigs" was obviously a very satisfying job. I remember saying when the job confirmed, it's very rare that I get to work on a commercial for a product that I genuinely buy every day. I could only think of one other product I used every day, and that was Colgate. Colgate, PG Tips, and the *Guardian*, and that's it. And obviously it was a really good ad, and a really good agency, and the Guardian guys themselves were fully on board—it was the first advert they'd done for twenty-five years.

The concept was the story of the Three Little Pigs told in the modern day, with modern-day media. That was the script, but then Ringan came at it from his angle, which is quite enigmatic and dark at times. You could have easily done that in a very different way. You could have done it animated, you could have done it in bright primary kid's colors.

Many different ways. Ringan did it the way he wanted to do it. He had a lot of specific visual references, which we incorporated into the treatment, and which he talked over thoroughly with the cameraman. He had a specific look he was going for. But you could have come at it from a very different angle— ended up with the same story, but with a very different mood. It wasn't too long after we shot that that the Arab Spring happened, and you had kids rioting in the streets and using Twitter, so it became even more real as the world progressed. Even now whenever you see technology interacting in TV shows and dramas, quite often they just do a screen grab of the computer screen, whereas Ringan used it to transition through different scenes, and it was a really clever way of doing it, and very original. I hadn't seen it before.

Corran Brownlee: Storyboard Artist

The Brownlee Brothers are artists and directors originally from Calgary, Alberta, Canada. Among other various accomplishments, they have story-boarded a large number of acclaimed advertisements, including Adidas's "Impossible Field," Pepsi's "Mountain of Everything," and Guinness's "noitulovE."

Beginnings

There was a little bit of a boom in Calgary as far as the film industry went in the early nineties, and there weren't any storyboard artists. I was doing painting and fine art stuff, and got hired on this Disney show to do storyboards. It seemed I was literally the only storyboard artist in Calgary, and then my brother started doing it as well. We kept at it, and when we moved to the UK—our dad's from Scotland and our mom's from London—it was kind of on the back of a Hallmark miniseries directed by Steve Barron called "Dreamkeeper." We'd done hundreds of pages of storyboards for that, and it was mostly on the visual effects side of things. We actually got Emmy honors for our contribution to the visual effects designs on that one. So when we got here, Steve was doing a project for Danny Kleinman's old company Spectre, which then went on to become Large, which then went on to become Daniel Kleinman, and ultimately became Rattling Stick. So we started working with Spectre.

The visual effects for that Hallmark miniseries were done at Glassworks, which is a visual effects company down in Soho, London. A lot of networking goes on in Soho, every Friday evening in the pub, and we sort of met everybody. We got into the commercials pretty quick and only did a couple of films here, as far as storyboarding goes. What we found with the commercials was that they were so much quicker. You can work one week a month for ads, and then you can do your own thing. I guess we could have made a lot more money if week after week we did storyboards, but we wanted to develop our own projects.

Storyboards

There are different times you use storyboards. There are the brainstorming storyboards, what ideas can we come up with to make this stand out. Then there are the storyboards for a client, or to win clients, and those are usually a lot more aesthetically pretty: the drawings aren't rough, they're nice looking, they're cool, edgy or inoffensive—whatever they think their client's going to want. Then there are the production storyboards, which are a little more rough. They tell the story to the crew more than to the client or the viewers, to tell the crew what the shot's going to look like in the end—it's going to have a mountain in the background, say—and show them why they're bothering to wake up at five in the morning to set up the shot. Then there are the more technical storyboards where there are more arrows involved, and dots, and pointing, and description and stuff like that, and you can actually put those on a monitor on set. I never really feel like there's ever a specific time when you need storyboards; they're useful for different moments in the process.

What to Draw

The commercials that I dread a little bit are the ones that have crowds of people in them. Or just lots of detail. Like the Pepsi one we did with the mountain of everything, it's a fun commercial—finally something that is surreal and cool-looking —but it's just the sheer amount of drawing. And those have to be a little more accurate —draw a Rubik's Cube, a VCR, a neon sign, a shoe, and now a comic book. Then the comic book has to have an image on the front so people know it's a comic book, so what image can it be? We actually had to come up with a comic book that didn't exist and think up a superhero, and we had to go through copyright and all that. It's fun the amount of creativity you have, but you kind of dread it because of the sheer amount of drawing in a little amount of time.

OPPOSITE LEFT: Pepsi "Rising (I CAN)" (CLM BBDO/Rattling Stick, d. Daniel Kleinman; storyboards by Arran and Corran Brownlee).

OPPOSITE RIGHT: Cadillac Escalade "Tiki Barber" (Modernista!; storyboards by Arran and Corran Brownlee).

A lot of the times an ad might change from the storyboard because the set's not even built yet and the casting's not there, and it's not until you're on set that you realize, oh I guess we can't do that. You'll sometimes have the location photos, but those photos aren't necessarily accurate, or they'll be with a different lens so you don't really have a good idea of the space, and a lot of times they'll be at the space but they'll flip the direction, so it can change quite a bit.

On some jobs they don't know what they want until they see it—you'll keep giving them ideas and ideas and ideas, and they'll take one or two and leave some. We did some boards for the Sci-Fi channel when they changed their name to SyFy. The script basically followed a couple as they walked through a house filled with wonders. We had to come up with a bunch of crazy surreal things to fill the house with, and the director picked which ones he liked. It was done through MPC [The Moving Picture Company—post house], and we knew some of the producers there and the effects guys. MPC said we could go through their library of things that would be assets and that they could build easily. A lot of the ideas came from effects MPC was developing but didn't have a project to use them in.

How to Draw

The thing that we started doing that was different was we got on these computer tablets not long after they first came out, in the nineties. Back at my first storyboard job, I did the first season of the show in pencil, and the art director was trying to get me to do it one of these things. As soon as I did, what I found was that it can actually match what the camera is doing more, what the lens sees. So you can do, say, a rack focus storyboard, whereas before when I did it in pencil,

if something went out of focus I'd smudge it with my finger.

More often than not we work from the script, but I actually prefer it when the director's done something visual, even if it's literally just stick figures. It makes it easier, because part of the problem with storyboards is they never call you with enough time. They'll call you on a Thursday to see if you're available, and what they mean is, come in Friday for a meeting and get them to us by Monday. So it's nice when you go in and someone says, oh I've drawn up some ideas. It's kind of a relief because you don't have to sit there and do the blocking. Sometimes there's just a gag that needs to be worked out physically. You just have to scratch your head for hours first before you get to the actual drawing part.

Whenever we do boards now we make them really small. For one thing they take up too much room on the computers. They're small, but they get the idea across. There's something like forty panels for that one Pepsi commercial, and it's nice to look at them all together rather than look at the detail on just one. Another reason why we have them smaller is because you want the implied idea rather than too much detail. I've noticed some directors don't want a lot of detail, or they don't want to be too specific about certain things because they don't want it to bite them in the ass: they don't want someone to say later, but you said it was going to be here, look at the storyboard. They'd rather it was just a shape, just kind of there. But the Pepsi board was for sparking the imagination of the people who are going to be throwing it in there. And for the lighting guys and the visual effects guys it sort of hints at an atmosphere and it hints at a feeling that this could have.

The other thing is that a lot of DPs appreciate the lighting we put into our boards—you do flares and make a more dramatic atmosphere when you're drawing in Photoshop. We still try to keep the

OPPOSITE: Storyboard for Pepsi "Rising (I CAN)."

01-

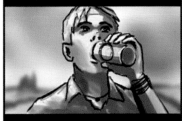

02-

03-

04-

05-

06-

07-

08-

09-

10-

11-

12-

13-

14-

15-

16-

17-

18-

19-

20-

21-

22-

23-

24-

Arran & Corran Brownlee www.brownleebrothers.com

drawings a little rough because what's weird about the advertising world is that you'll get notes back sometimes on storyboards where they want you to "add a smile." Literally draw a smile on someone who just bit into a fishstick or something. But it's more for clients half the time than anything else.

The storyboards are almost always in black and white, but once in a while when they want an edge, when they want to sell an idea a little more, it'll be in color. There was a British Airways ad we did where there were dolphins in the sky, and a little kid looking out the window of a BA plane at these clouds making dolphin shapes. That one we colored because we wanted to show the sunset yellow by the end of the commercial, not just blue skies and white dolphins. There was a Johnnie Walker one with a tree that we colored too because that was a pitch storyboard for the actual commercial, and it has a bit more influence. We did one years ago, a Levi's commercial where a woman's on a horse, and she's riding it on these train tracks. She comes out of a tunnel and a train's coming towards the tunnel, and she hooks her Levi's on these straps on the horse's saddle and she's playing chicken with the train, jumping over it with the horse. We boarded that one out and colored it slightly—we just did a blue bleach thing over the top and made it really stylized.

Changes

Working with Danny, we'll take the agency script and Danny's treatment—he puts a lot of thought into his treatments, but he doesn't get really specific about shots at the beginning. We'll try to send him more than he needs. A lot of the time

JohnnieWalker 'Tree' page2 (colour)

11-it's out of the woods
-moving down a hill

12-tilt up from the path the tree left behind.

13-

14-rural house in FG
-tree moves in distant BG.

15-

16-Tree arrives at motorway.

when you see all the shots you think, oh it would actually be better in this order. He'll send us notes like, we're missing something—we need an extra shot of the dog wagging its tail, and so on—and we'll add that, but we'll usually only have one or two changes.

It's fun sitting down with directors. I think it's fun for a lot of directors too, the storyboarding process, the creative side, because they're ideas you don't think are going to be nixed yet—wouldn't it be awesome if we did this? Yay! Then the changes come back and they don't get to do what they wanted. Boo! But at least they have that little drawing of it.

Technological Assistance

Video storyboards are becoming more common. They'll go straight to the visual effects company to put in a 3D model of a person, or a car, or a neighborhood, or something. One of the last ads we did we used the Google program SketchUp that's used by a lot of draftsmen and set designers. My brother and I had been using it a bit on this animation project we're doing [*Space Heat*]. On this particular commercial, there was a floor plan that the art director drew up. I took the floor plan into Google SketchUp and I built it, and then put these little placements for people in it, and then just moved the camera around. I still had to draw it afterwards, but it's such a great way to do it. It's funny how every few years there's a new tool that comes along that makes the process so much easier.

We've worked on a lot of animatics, usually to get pitches for people who really want the ad. Sometimes they work, but sometimes it's better to save the animatic till you've actually got the job and you're now wanting everybody to be on the same

page; to be careful for stunts; and everyone to be aware where the visual effects are happening—let's get this shot to look as much like this as possible because Framestore's building this movement. Sometimes if you're going for the job and you make this animatic, they don't look so good—they always look like bad animation because you're not going for any awards or anything. But what I love is that they get the idea across. It takes a certain eye—you have to judge who it is you're going to show it to. Some people will look at it, like a lot of clients will look at it thinking what the heck? Our tires don't look like that.

The tools are there; what's hard is keeping up with them. When we directed this short film [*The Continuing and Lamentable Saga of the Suicide Brothers*] we had to be really accurate with the visual effects ideas. We had three VFX companies working on it so we learned Combustion and Shake that week, squeezing just enough in our heads so we could show them the path of where the fairy's going to fly, or where the snow's going to fall. We'd composite it ourselves and say here's what it's roughly going to look like. We made it look as good as we could, added fairy sparkles and all that. But they really are all there. You can build entire environments. But after that week, when we'd passed the footage onto the guys who were going to do it for real, everything we learned about the VFX programs faded from our minds Programs like Maya or even Google SketchUp are as complicated as they need to be, but I sort of wish that programs were a little more—accessible's not the right word—perhaps user-friendly. There's a couple of interesting ones where you can sort of sculpt in 3D as if it was virtual clay—you can do it with your tablet as it's pressure sensitive—but even that one's a little complicated. So everything's there, learning it all is hard. And by the time you learn a new program, someone has come up with a better one.

BOTTOM ROW: Pepsi "Rising (I CAN)" (CLM BBDO/Rattling Stick, d. Daniel Kleinman; storyboards by Arran and Corran Brownlee).

Different Projects

The Pepsi ad we did for Danny was visual effects-heavy, a kind of surreal ad, as a lot of his ads are. There was this kid walking up to a mountain of his past, so the note was: we need a mountain made up of everything. There were a couple of concept renderings from Framestore, the visual effects company, that were useful. But that one was brutal because before you even start drawing you have to come up with a list of everything that could be in this mountain, from his whole life. We put things like a cassette tape in there that said "mix-tape" and that ended up in the ad (changed a bit, not with a hand-written label but printed). We had a subway with commuters for when he started his first job, with the commuters actually inside. Sometimes storyboards will affect extras casting—you actually put in a drawing of a train car with people smushed in it that he has to climb up, and because it's a good idea they decide to shoot it, so they have to cast extras and put wardrobe on them and that kind of thing. Those moments are kind of cool where you think, wow, I can't believe they actually went for that. Danny's really good at that though, and it's kind of easy to know what he'll like after eight years of working with him.

Sometimes there'll be an animatic, like on the Guinness commercial we did with him once, "noitulovE." We started on that one doing boards but we realized they had to be more. We were talking with creatives as well as Danny—it was a pretty long process—and we ended up just making our storyboards into an animatic. Sometimes drawing an arrow isn't enough. We got together with this Flame artist at Glassworks and animated it to show how it would look. That one was funny because there were goofy moments in it but it was put to a very serious soundtrack and it was a lot more

epic, the original one. In the end they changed the soundtrack to have a little more of a comedic edge, like the "Rhythm of Life" song. It just gave it that extra bit, made it a Danny Kleinman classic rather than something that could have been taken too seriously.

That was a good project because it was a long one. One of the hard things about advertising storyboards is the all-nighters. It's very rare that we'll do a storyboard job where we get to sleep before three or four in the morning. It's partly because the timeframe we're given tends to be short, and partly because Arran and I aren't the fastest. We often turn down jobs where people phone and ask, can you come in this afternoon just to draw up something. They'll always say, we just want something rough. We're not really the guys who do that. I can sit down and draw roughs throughout a meeting, but we've discovered throughout the years it's just not how we work best. We work best when we can take into consideration location and shots and lenses and lighting. There was a really complicated one we did a few years ago for Adidas called "The Impossible Field." It was all the big football players just playing on the white lines of the pitch, so Danny and Arran and I (none of us play football) were wondering what kind of moves could you do. Arran and I took a couple of days just trying to think of moves. Danny wanted to use the different levels to make sure we don't just stay on top of this thing, so we had guys swinging underneath to kick the ball and stuff like that. It was fun, but it was a lot of choreography. They used some of our moves, and they used a lot of our shots, which was cool.

Then there are other ones like a Johnnie Walker one we did years ago called "Tree." It was just about a tree that uprooted itself from the forest, slowly walked across the countryside through a rural and then a

more urban setting, to this corporate setting, and then just planted itself into a little courtyard down in the banking center. It's kind of an easy one to draw, because it's just a tree; a tree going through a lands-cape, going past buildings. You can literally take your camera and go out and take some photos, go through all the photos you have, or go through location pictures and say, oh that's a good shot, and sort of trace over it. They're really easy ones. You can focus on making it look pretty.

"Sometimes storyboards will affect extras casting—you put in a drawing of a train car with people inside, and because it's a good idea they decide to shoot it."

Chapter 3
The Shoot

Once the script has been approved, the production company and director selected, the storyboards and all pre-production completed, the actual physical process of filming the commercial can begin.

Logistics

Inevitably, the size of the production will depend on the budget, which in the conventional course of events is a trickle-down number from what the client is paying the ad agency, to what the agency is paying the production company and what, from that and other projects, they can allow for this one particular commercial. While many productions can look no different from feature film sets to the casual intruder, with numerous people scurrying about (and an equal number perhaps sitting around), rows of trucks and an endless supply of equipment, many production companies, and even agencies, have been exploring the possibilities afforded by cheap and easy digital technology, and the increased tolerance for home video-type YouTube footage. Small documentary-style crews can capture high quality material which, if it conveys the message in a distinctive and/or persuasive way, can have as much impact as those shot by production crews in the hundreds.

The preference remains for a full, professional crew and an at least reasonably controlled environment. The pay-off of studio versus location remains unchanged also: a complete control environment versus the uncontrollable magnificence of something that would never or could never be built. Makers of films, manufacturers of any kind, have always sought cheaper ways to produce their product abroad, and ad-making is no different. The commercial-making industry is so truly international, however, with key figures coming from and working all across the world, that it makes little practical difference to the actual process of shooting a commercial, local character aside, where in the world one does so. Of course, many ad-makers would nevertheless prefer to shoot in the Bahamas than in Basildon.

There are multiple decision-makers on set, from the director to the line producer to the executive producer to the agency producer to the representatives of the client company. There is a script, which has gone through enough scrutiny in its concept and proposed execution to be well-polished. The creatives will also be present on-set to provide new ideas, but the basic story, feel, and message of the commercial are more or less inviolable by this stage. Nevertheless, shooting encompasses a constant attention to whether or not individual scenes, shots, performances, etc., can be improved upon. Before individual set-ups are broken down, the chain of decision-making is consulted, so that everybody involved feels satisfied to move on.

Some clients are very experienced, and very helpful to the process, but others can be less so. They will be gathered with the agency creatives in the video village, and after every take, before moving onto the next shot, the ad agency in consultation with the client representative will okay the next set-up. This is to everyone's advantage, since nobody wants the client to be able to say later on that the director and production team never captured what

they had proposed to capture. The client is paying for the whole thing, and the buck stops with them. The agency works as a buffer between the production company and the client, so the client will talk to the account person at the agency, who'll talk to the creatives and the agency producer, and then the agency producer will talk to the production company. This all happens on-set, the various parties within a few feet of one another, but it's a strict chain of decision-making to avoid too many competing voices and to prevent confusion.

The Onset of Digital

Meanwhile, the director and his crew are patiently working their way through the shot list, attending to all unexpected occurrences, and trying to make the best little film they can. In fact, the explosion of new media platforms has meant that a production team will frequently find itself shooting more than just a film. With new, versatile cameras, a shoot can encompass photography for print and billboard advertising, filming for the actual TV commercial, and then longer (and shorter) form pieces intended for the web, if not shooting solely for Internet distribution.

The jury is still out on the effect that digital photography has had on the commercial-making industry. Many directors and DPs remain adamant that film technology is still better, faster, and cheaper, and can actually work better in low-light scenarios. Then there are plenty of others who think the opposite. Both celluloid and digital have advantages and disadvantages. There is a certain cost to film, and an interrupted workflow for magazine changes, as well as the developing and telecine stages after the shoot. From a production point of view, the speed and cost of digital are very appealing. One additional advantage is the quality of the ubiquitous video assist: with film, the image tapped from the camera to the video monitor will typically be degraded to the point where its usefulness is limited—to get a proper impression one has to physically go and look through the camera, which is not

always possible. With digital, however, the monitor image will be a more accurate duplication of what is seen through the camera, in dazzling high-definition resolution. A slight downside of this for the directors, on the other hand, is that the agency and the client representatives gathered in video village can look even more closely over their shoulder. On an annual basis, digital production, as opposed to film, is increasing at a huge rate. Surveys conducted as recently as 2010 showed that about 25% of commercials were being shot on some sort of digital medium. Only a year later, from data gathered from film camera rental houses, that figure had increased to 50%, and the slide continues with new generations of cameras like the Arri Alexa, and the models from Red and Canon. Digital technology continues to improve and refine itself, so for Panavision, for example, instead of looking at developing the film body cameras and their lenses as they were only three years ago, they have now adjusted their business priorities to developing lenses for all the various digital platforms available.

Filmmaking to an extent is a gadget-driven industry. There was a point around 2010 when every director and DP owned a Canon 5D DSLR, whether they knew how to use it or not. The annual trade show mounted for the digital media industry by the NAB (National Association of Broadcasters) is dominated by cameras, and considered a premier launching pad for new models. As technology improves across the board, however, the decision faced by a director or DP is less to do with whether one camera is better than another, but which is most suitable for the job. It's an equivalent to the days of film where choosing a Panavision camera or an Arri, or choosing which stock to use, was a creative rather than quali-tative decision. Certain cameras do certain things better in certain situations, so as with considerations of genre, tone, and technique, directors are now able to pick from a wide array of technological options depending on what will best fit the idea and message of the ad, be it film or digital, or even 16mm or Super8. If it works for the idea, then that's the reason for using it.

OPPOSITE: Monster "Double Take" (BBDO/Rattling Stick, d. Daniel Kleinman).

BELOW: Monster "Stork" (BBDO/Rattling Stick, d. Daniel Kleinman).

Daniel Kleinman: Director

Daniel Kleinman has been rated number one in both Campaign and Televisual's list of hottest directors over four consecutive years; he has been recognized by the Gunn Report as the foremost awarded director in the world; he has been honored for his work multiple times by every major commercial awards body; and he has been voted the U.S. commercial director of the decade in Ad Week. Through his production company Rattling Stick, his work includes such commercials as the John Smith campaign with Peter Kay, Guinness "noitulovE," Smirnoff "Sea," John West Salmon and many others.

Initial Pitch

What I might receive initially on a job is actually very varied. It can go from the sublime to the ridiculous. It can be a very open brief where an agency really has little more than aspirations, not a script as such, or they might have an idea that's formative and want help to flesh it out, to collaborate and to make it work. At the other extreme I might receive something that is very highly worked out and has been through lots of testing in every single nuance, and is locked in stone. So each project is quite different—personally I prefer a script that is in between the two.

The Script

The best script is one with a very simple idea, or a very clear idea, and something I feel is interesting, that I've not seen before, a different take on something. The interesting ones will immediately throw up images in my mind; I'll get ideas about what it could be from the page. Sometimes —more often these days—agencies will also send some visual reference, pictures of a mood or whatever, which can be useful to generate a spark in the imagination.

If I can see something in the script I can be excited about that sparks ideas and that I feel I can develop, then the first thing would be either to meet with the agency personally, or more commonly these days to have a conference call. This is to get a sense of whether what I imagine is the same as what they have in mind, or at least that they're receptive to what I'm imagining. Eventually these days, it's more or less a given that you then have to write a treatment. We didn't have to do that when I first started directing—you'd just go to a meeting where you explain your ideas, and everyone, with luck, would say that's great, and the next thing I'd be filming it. These days, directors really

have to put things down in a coherent and extensive treatment, which will be several pages long, with illustrations and reference.

The most helpful aspect that advertising agencies should be good at is knowing their clients, knowing the client's product, and knowing what the client's trying to achieve. Obviously I come in cold, and I've got no idea what the underlying aims of the campaign might be unless I spend a week's seminar getting to know their client, something I'm unlikely to jump at. The main objective is usually to sell more stuff, but not necessarily so: it may be to change the perception of the brand, or the demographic of the consumer; it may be P.R. after some disaster or a change of name, rebranding for some reason; or it could be to appear more modern or more like a heritage product. So I prefer it if there's a good tight brief and the bare bones of the idea at least; they've got some kind of script together, but not so fleshed out that I can't add my own stuff to it. I feel, as one gets more trusted, you're looked to perhaps for more and more input, which is why I quite often get scripts that are really very sketchy. Even though it's flattering to think that I can I write the entire ad, I'm not really inclined to do that. From a production standpoint, not to seem too money-motivated about it, if you're working on something and spending weeks on it before it's an actual approved job, and you're not a salaried agency employee, you're just working for free. So ideally the agency should have a fairly progressed script together, a bit of work done, before they come and get production input, and the project's at a stage where the client has agreed to the ideas in principle.

A classic, undesirable situation is where the agency is asking for a lot of input, help to make their strategy into a great ad, but you get the feeling that, hang on a sec, am I being used to pitch this to their client? Is it actually a script that the client's bought or, perhaps, do they even have the account? Sometimes an agency

can be sneaky and try to use you, the director, as a way of helping their pitch to get an account, to have more weight by having a "name" director attached. Although they are trying to win the business, if everyone is upfront about it and you love the idea and sign up for a go, fair enough; but if that information is withheld it's very unfair because, as a production company, you're actually investing a lot of time, research money, staff, and wages into trying to make it work. Effectively you're being used as a free creative resource. The workplace is competitive enough on a real job, and obviously the chance of recouping the investment for your work on a job that may never happen is much less likely. So if a script does require a lot of work upfront, I try to confirm it's a real job, bought and signed off by the client.

Fit the Ideas to the Project

For me it is always about the idea, so I ask myself, does this script, this ad, have at the kernel of it a great central idea? Then, if I feel it does, I fit the genre and the style and whatever else is required to that idea. I try not to think in formulaic terms. I certainly wouldn't class myself in the same league, but my big film hero is Stanley Kubrick, and if you look at his work, he really never did the same thing twice. He fit the style around the core idea of what he was doing; consequently, he was inventing the most brilliant way he could make, say, *The Shining* super-scary and psychologically disturbing, and he produced one of the quintessential best horror films ever made. Or in 2001 he invented groundbreaking science-fiction special effects. It's much better to treat things that way around, starting with the idea, with the techniques and the approach coming second. Quite often a new bit of a equipment comes out, or there's the latest fad or fashion for doing some sort of strange effect, or animation style or something, and it's tempting to write an idea to fit that style, but invariably it's a disaster or at least won't stand the test of time as a piece of good work.

ABOVE: Smirnoff "Sea" (JWT/Rattling Stick, d. Daniel Kleinman).

Be Eclectic

In bygone years it was possible to break all ads down into different categories, and in some areas people still do that. There are guys who just do hair or drinks, for example. You might be the go-to guy for food, or say you've got a beer commercial where the whole ad is about condensation running down a bottle and how liquid fizzes over ice, then you want a specialist director who just does that. I can't do it, and I'm not really interested in doing it to be frank, but of course some people really enjoy being very good at just one aspect of filming. I'd say at least for the last ten years and probably a bit longer, it's much better to be eclectic and have an ability to turn your hand to any genre, to avoid being pigeonholed. So I tend to think of ads not in groups, like this is a car ad, or a comedy ad, or this is an ad about banking. I just ask, is this going to be a good ad? It's one of the interesting things, and one of the reasons I enjoy my job, that literally no two projects are the same, and I'm totally amazed at how constantly and how many times on each job I find out something new, gain a new bit of experience, or get to try something new.

A Creative Team

One of the things I started out doing was storyboards. That wasn't my job—I was an illustrator. Actually, I went to art school to learn to paint. I had some friends making music videos, and just as a way of earning some more money I would help them out by thinking up ideas and drawing storyboards and planning the outlines of the videos. Sometimes for certain projects I do still draw all the boards for a commercial myself, but not always, and not only because I don't usually have the time to do it. I like to work with storyboards —it undoubtedly helps, and if I draw them myself in theory there could be less room for misunderstanding. But advertising is no different from any other kind of filming in that it's a collaborative process. As long as all the people you're working with—like your cameraman, your producer, your art director, and your storyboard artist—are really good, then they can bring something to the work that is in addition to your vision. I probably have enough knowledge to stumble through most of those jobs myself: I could produce it if I felt like it, or given that I've been on sets for the last thirty years, I could light it, but I don't.

Of course I couldn't physically do every job on the set, and I don't have an Orson Welles complex. But what I'd really miss if I did do everything myself would be the potential improvements that collaboration brings. I work with artists that I like, and I encourage them to add ideas and add thoughts. I can always say no, or change them. A director can always say, "I don't like that, do it like this"; on the other hand, I like to keep an open mind because often things that are suggested are good, and if they work well, I can claim them as my idea. That's flippant, but the point is to make the best advertisement you can.

I have a team of people I know and trust, but I don't work with the same team all the time, as that can also not be such a good thing. So it's more like a pool of people that I draw from for specific projects, and there are really two criteria I look for in crew: the first is to be good at the job, and that I consider them creatively excellent people, and they really know what they're doing; the second is that they're nice and I can get on with them. Every director has a different style: some thrive on anxiety and shouting, everybody being uptight and freaked out and living on the edge, which just isn't the way that I like to work. I like things to be very calm and friendly and good-natured and worked-out, and for the process to be as pleasurable as possible, and I prefer to like the people I'm working with.

Chain of Decisions

Something that seems to be happening more and more these days, which I think is to do with the expanding scale of companies, certainly big client companies, it's that you may not be talking to the boss, or the person that has the say or final word, even if you think you are. Sometimes you assume something can be signed off because the responsible person has seen it and liked it, and then you find out actually

he's just got to take it to his boss, and then if that boss thinks it's great he'll say, well we've just got to send it over to Japan to the head of the entire global company to approve it. If at that point, you've put a lot of effort into, say, building sets, hiring actors, and major things like that, then someone pops up the day before the shoot saying, no, no you can't do that, everything has to be yellow, obviously it can be very frustrating. So before the shoot I try to find out if everybody who has to sign off on things has signed off on them early on, and it's surprising how many times that doesn't happen. I think it's just that these guys are great big jet-setting international heads of this and that who probably don't have the time. It goes all the way up from talking to the creatives at the agency, who then have to take it to their creative director, and the creative director has to talk to the account director; the account director has to talk it through with the junior client, the junior client has to talk it through with the head client, and then it just goes up in this sort of hierarchical never-ending tower of more and more important people stretching off into the clouds. It's likely you'll never really get to know or meet the people who in reality have final approval.

Sometimes it may be because employees are worried about saying, "Yes this is great, go and do it," because their ass is on the line. Filming is an expensive business and advertising is expensive, and they don't want to get it wrong; they don't want to be in line for the chop because they've stuck their neck out and said something that somebody higher up doesn't like. On top of that, and partly because of that, there's now a great deal more research and testing, focus groups and all that, which can of course be helpful but can also be nonsense.

A symbiotic occurrence to the unbelievable number of sign-offs that you may have to get from all sorts of

people, and it actually happens more frequently than I would like, is that you set out thinking you're making one ad and then you find it has transformed into something else entirely. You might think because you've had all these meetings, talked it through from all angles, had conference calls, done sketches, done storyboards, pre-visualizations, and animatics, everything is fine. You and the agency know exactly what you're doing, and you're excited about it and then suddenly everything changes, the goalposts move. "You can't have this, it's illegal to do that, you can't make this joke," etc. At that point, I suppose you have two options: you can either walk away and say, balls this wasn't what I signed up for, and leave, which I've felt like doing occasionally, or you can follow through with a lesser version of the initial creative idea. I haven't ever walked away, partly because I'm not egoistic enough to think that what we're doing is high art. It's a service industry

after all. But also, once I've signed the contract, even if things change, I'm being paid to do the best I can with the project, and unpredictable change is part of the nature of the business. Also, even if it starts going wrong, I feel a professional responsibility that means I have to try to see it through and make the best of it. I will feel depressed that it's not what I thought at the start though. Some directors do walk off, but I feel you've just got to get your head down and do the absolute best job you possibly can. The day when I don't care about the end result, and I loose focus on trying to make it as good as it can be, is the day I'll give up and spend more time with the sweetpeas.

On the whole, however, I enjoy the process, and I wouldn't take on a project that I didn't think had something interesting about it. Sometimes I do take things on even if I think the end result is not going to be world-shattering. It might be because it's something I've never tried before, or an

idea I wanted to experiment with, and I always try to make it be as good as I possibly can.

The Fluidity of Filmmaking

There's quite an interesting kind of disconnect between clients and agency and the production side of things, in that clients and agencies sometimes believe that filming is a very exact process, that you work it all out beforehand, you do all the testing, do all the preliminary stuff, and once you've got all your ingredients for the cake and you make it to the right recipe, being very careful about everything, then it turns out to be exactly what you're expecting. But filming just isn't like that. It's a mercurial, often spontaneous,

slightly uncontrollable process, with a million different variable factors. That's partly why you'll get the classic situation of the agency or the client getting very fixated about a very minute thing. It's not unusual that someone gets completely wound up about the pattern on a tie for instance, or some out-of-focus extra sitting in the background, but they're missing the enormous overview of what is going to make their ad great, or not great. As it's not an exact process, you can't just go in thinking, oh, I'm going to do exactly this, and exactly that other thing exactly this way. One has to keep an open mind when filming and be able to adapt and adjust and to work flexibly, to take into account all the variable factors that might happen. Obviously the weather is a major one. If you're filming in the desert and you

BELOW: Carlsberg "Spaceman" (Fold7/Rattling Stick, d. Daniel Kleinman).

need it to be baking hot, Murphy's law says there'll be a downpour and some location person will say, "it's never done this in forty years." That happens—it's amazing how often—ask any director. I was just shooting in the desert recently; it was a sequence of a mature guy running in the desert. We'd done extensive casting of runners who could run all day, and they had to look good running. I did a first take, the man we picked ran, took four steps, twisted his ankle, and couldn't run again. We had medical people there obviously, they said no more running, we were in the middle of nowhere, so we just had to get an extra, vaguely the same size, to put on the first guy's wig, pretend to be him and do all the running, negating about two weeks of casting. It's exactly those sorts of things you can't predict. Good production

is about second-guessing and preparing for a thousand scenarios like that, but things you don't expect will happen, and you just have to try to adapt to them. There is such a myriad of potential mistakes and hazards that it can be like a minefield, this job. There are many things that simply through experience you learn to be aware of and look out for. I think that's why experience frequently does count for something, in that you are more forewarned and wary of potential problems. But through long experience I'm not surprised when problems do surface after the most meticulous planning, so I constantly feel I'm still learning.

It's All Worked Out . . . Except When It's Not

I think everybody works in a different way. Personally, I like to work out what I want beforehand, and then I try to shoot what I have in my mind. But I'm still very keen to have an open mind, so that if anything fortuitous occurs, you can embrace it. Sometimes one deliberately shoots in a fairly wild way: say you have a shot of a car going at sixty miles per hour, and you want a really fantastic low-angle three-quarter shot, the angle the client really likes, and you want the background to be just right and so on. It's very difficult to set up solely that two-second bit, where everything is absolutely right, the shadow's in the right position, the car's doing the right turn around the curve, the reflections are right, and so on. If the camera is tracking it's virtually impossible, unless you're using CG or something. In general you don't just shoot exactly the length of shot that appears in the edit, you run up to it and past it. So a very sensible way of filming a car, for instance, is to have what's called a "pursuit vehicle," which is car with a camera attached that runs next to the hero car, then you drive up and down the road, throwing the camera around and getting tons and tons of really great material, and then just picking the best shots. That's a bona fide way of doing it. But on the whole I tend to like thinking of what sort of shot I want and then trying to get that kind of shot. Of course you can change small things; you can have ideas on the set, you can come up with things where you feel, actually, it'd be better if we looked this way rather than that way, but to reinvent the entire ad from scratch is not advisable. Different people have different ways of working, of course. Tony Kaye used to film with many cameras running all the time, and he'd be getting lots of spontaneous reportage-type footage that looked amazing and very natural because it was people doing all sorts of things, almost as though they were off-camera. But in the present fiscal climate that approach is a tough one to sell. Being Erich von Stroheim, strolling in at eleven in the morning saying, "I don't like this set or location, let's go and find a field to do this in instead," doesn't work anymore, if it ever did.

The Director in Post-Production

The two worlds of production and post-production are becoming closer. It's more usual now for the director to see a project through to the end, something that's always been the case in the UK but certainly wasn't in the U.S. Traditionally, in America, the agencies didn't want the director involved in the edit, I think, because of an attitude left over from an historic period when the advertising agencies used to do all the editing and music in-house. To an extent that still holds: the agency will frequently send the edit out to an edit company, and quite often the director waves goodbye at the end of the shoot, and that's the last time the director is closely involved in the project.

However, that is changing. I think in America now there is more interest in a kind of auteur-type director vibe. Sometimes it might just be lip service, but more and more they do want you to feel like you have some input into the post-production, and into the edit, through to the end of the process. So on the whole, agencies allow and encourage you to do your own cut. I think actually there were also some changes to the union rules of the Directors Guild of America saying that the directors have to be able to do a cut if they want to. I always do, although whether the director's cut is used is another thing. Sometimes I'm surprised—sometimes my cut makes it through or is at least used as the bones of the piece, but

also occasionally I hardly recognize the piece. In England, it was always very different: the director would see the project right through to the end, so I'd sit with the editor, the agency wouldn't be there, and then I'd present a cut to them. They might want to change a take or tweak a little something, but it wouldn't be the case that they would reinvent the whole thing. The director would also oversee the music, the special effects, the color-grading, the sound effects, and the whole shebang right to the end.

Director's Cut

The director's cut as an alternative version, however, is another matter, and for me I feel it's a pointless exercise. I can see why it may be relevant to younger directors building up a reel, however, working on a project that they're very passionate about; if they then get brutalized by the agency and by

the clients, and all their original optimistic views of how they're going to make this a great film are beaten out of them, then the director may want to show how it would have looked if it had just been left to him or her. They'd want to show off the spot as they'd conceived it and do it as a director's cut. I can understand that, but the reality is that not many people even in the business are interested and hardly anyone will see it, and after doing this for a long time I don't feel like I need to prove anything in that way, and I'm not interested in showing off to anyone. As far as I'm concerned the ad is the ad, and what goes on air is what people see. If I've not been able to make it good then I've failed in my job. I don't really like the excuse of a director's cut to say, you know, this is what it should have been like. I also think it's rather narcissistic, particularly as it's just a bloody ad, not a feature film or something. I'm not a big fan of the director's cut per se.

Changing Climates

In England, it's actually moving a little bit towards the old American way, where agencies want to be more controlling of the edit; perhaps the two methods are going to meet mid-Atlantic. It was also always a slightly quid pro quo thing in the American tradition: directors mightn't be too worried about not being involved in the edit because it takes a lot of time. You get paid a director's fee based on shoot days, but you certainly don't get paid any more for doing the edit. So if you wave goodbye at the end of the shoot, you can go off and shoot with somebody else because you're not stuck in the edit for the job you did last week, which means you can make more money. It's was just a sort of cultural difference between America and England, and I believe that arguably in the past British commercials were superior, possibly because they were the vision of a director who had worked

on it from beginning through to the end with more consistency. But as I say, things are changing and today, in my opinion—American commercials are probably better than British commercials have been lately, maybe because of an inherent conservatism in challenging times.

Capturing the Popular Imagination

I certainly don't consider adverts to be fine art. I suppose you can call them a kind of folk or popular art. They are by nature essentially ephemeral. You hope they'll nail the zeitgeist, and sometimes you can get that right. I did a lot of ads with Peter Kay for John Smith's bitter, and at the time he was a relatively unknown comedian, not the megastar he is now. I was working with a particularly great agency writer, Paul Silburn, who wrote the amusing scripts, and Peter also had input. Directing him was a pleasure because he

OPPOSITE & ABOVE:
Adidas "Impossible Field"
(180 Amsterdam/
Kleinman Productions,
d. Daniel Kleinman).

was so enthusiastic—it was a bit of a break, or at least a boost, for him in a way, when the ads were so successful. They're fairly old now, but one of the commercials was a diving competition, and Peter had just done a bomb into the swimming pool. It was at a time when we were at war with Afghanistan, and the catchphrase of the ad was "top bombing," and for another ad it was "'Ave it." Apparently, the Royal Air Force was writing "Top Bombing" and "'Ave It" on the sides of the bombs it was dropping on Afghanistan. I can't honestly say that is something I'm particularly proud of, but it shows how recognizable the catchphrases became. I thought they were quite low-key ads, but they became extremely popular, with the phrases being used on the front of newspapers, and "'Ave it" even appeared in the Prime Minister's Questions in Parliament. Right sense of humor, right actor, right time.

You Never Know . . .

There are all sorts of awards around the world for your peers to vote for, or for the public to vote for based on which ads they like best or which ads have sold the most stuff. But on the whole I don't even feel that's a particularly accurate way of judging whether an ad is successful or not. I almost think a time-test is the best way to judge. For example, one of the classic ones is the old Cadbury's Smash "Martians" ad, which was some rather naïve puppets selling instant mashed potatoes. It's an ad I think most people—in Britain at least—would immediately remember, and would like, and it brings warm feelings when you think of the absurd puppets falling about with laughter. That was the sixties. Fifty years later people can still remember it and feel good about those ads, and every time there's a TV program about ads they are brought out. That's a pretty successful campaign. It would certainly have cajoled people into trying instant mashed potatoes, once at least. The makers would probably not have known at the time they were filming that it would become so iconic.

There was an ad I did for John West canned salmon, which is not a sexy product. It was just a little ad, I was told they didn't have much money, but it was a funny script, and I had an idea of how I could do it in a sort of counterintuitive way by making it more like a wildlife program than an ad. I didn't know at the time it was going to be quite as popular as it was. The year it came out it was actually voted America's favorite commercial, and it didn't even run in the States. It became known through the power of people emailing it to each other, which was one of the first times that had happened.

John West Salmon

What I received to work with on that project was a short script about a bear going down to do some fishing, and a fisherman runs out and tries to steal his fish. It could have been done in twenty different ways: there could've been lots of close-ups, it could have been all about the bear ripping the guy's head off, it could have been very slapstick. It could have been a real bear; it could have been an animated bear. All those things are open, and that's what the director brings to a project, those decisions. Weirdly, one of the decisions I made was the kind of thing that people look at it and think, I can't see what the director's done here, because it's one shot, and this is due to only a hazy grasp of the director's role. My decision was to do it all as one shot as if a wildlife cameraman happened to be caught slightly unaware by this moment of animal behavior. The idea was to try to hoodwink people at the beginning into thinking perhaps this is a real bear, and then to surprise them halfway through with the

ABOVE & RIGHT:
John Smith's "Dog Show"
(TBWA/Rattling Stick,
d. Daniel Kleinman).

"Right sense of humor, right actor, right time."

realization that, oh, it can't possibly be a real bear, and everyone's in on the joke, and it just makes it a bit funnier. Those decisions were directorial decisions. There was a knock-on practical benefit of my method: the bear suit wasn't particularly good, so I didn't want to get too close to it either. It was secondhand and a bit moth-eaten.

"noitulovE"

With the Guinness "noitulovE" project, the script was a short paragraph: three guys go into a pub, they start drinking, and then run out backwards and travel through different time periods. They turn back into cavemen and eventually end up as primeval animals who sip this muddy water and say "bleh," demonstrating that "Good Things Comes to Those Who Wait." The idea was to take the core Guinness thought, that good things come to those who wait, to the extreme of millions and millions of years of evolution. That was it; I had to come up with the run of events, what happened when, and would it work if they turned into this or that for instance. Most people who saw the script might want to make it into a kind of history film, where it's going back in a very logical way. I just went for the fun, it's absurd—they become fish and they become little flying rodents and they become dinosaurs. It's not got any connection to Darwinian theory; it's just a gag, it was meant to be amusing.

I worked out what the transitions would be, which segments were animation and which were filmed, how much whimsy there was, how much was played straight, a complex mix of decisions. Planning is particularly necessary on an ad where not a single shot is what you just see through the camera. It's made up of lots and lots of different things: animation, pieces of different elements that I'd shot, plants wilting under heat and constituted back, for instance, all sorts of different things. Altogether it was challenging, and challenging for the client as well; of course they want to fully understand what and how you are going to it. I did try to explain, and they'd ask, well what's it like? But I couldn't show them what it would end up like, because it wasn't like anything done before—I was trying to do something fresh. That sort of process can be a little tricky, but it was a perfect script for me. It had an interesting premise, three guys de-evolving; I could really run with it, come up with lots of wacky nuances, and by necessity use a whole mixture of different and interesting techniques. It was a script with a great core idea, well thought out, and a good gag. Plus, I like Guinness.

ABOVE: Guinness "noitulovE"
(Abbot Mead Vickers BBDO/
Kleinman Productions,
d. Daniel Kleinman).

Bruce MacWilliams: Director

Bruce MacWilliams began his career as an independent filmmaker before signing with Biscuit in 2002. Since then he has directed more than a hundred TV commercials and high-profile PSAs, winning multiple awards, and has been recognized by the Saatchi & Saatchi New Directors Showcase and the Shots Magazine Grand Prix awards. He has also been commissioned to write a half-hour comedy series for NBC, and directed a documentary on the 2008 presidential campaign. In 2001 he formed his own production company, Buzzsaw Films, which continues to work in the commercial sphere, as well developing feature film projects.

Getting Started

I started off directing independent feature films. I went to Cornell University as an undergraduate studying architecture, photography, and creative writing. After I graduated, I entered Columbia University School of the Arts, studying filmmaking, but instead of going into my second year to earn a Masters, I went out and shot a movie. This was an exciting time in New York, when Jim Jarmusch had just shot *Stranger than Paradise*, Spike Lee had just directed *She's Gotta Have It*, and the Coen brothers created the first of their several masterpieces, *Blood Simple*. And I was thinking, I've been playing with cameras since I was ten, this is right up my alley, I can do this, in fact, this is exactly what I should be doing for the rest of my life—filmmaking.

So at age twenty-seven, I raised two hundred thousand dollars from two hot shot bond traders on Wall Street, made a movie, was picked up by a distributor, and went to Cannes. I make it sound simple, and it's definitely not, making a movie (any movie) is extremely difficult, but at the time I was young, cocky, and slightly ignorant. I didn't know how hard it was, so it wasn't. Ignorance is bliss.

So I did it again, with slightly bigger stars, and a real producer this time, Bob Peters, who had a long history working at Paramount Pictures. I had a slightly bigger budget, and the movie was fairly successful, domestically and internationally. It looked like the perfect launching pad for me as a film director, but as I was putting together my third feature things slowed down to a crawl. The go-go eighties and nineties were over. My ignorance had, unfortunately, wizened up, and my bliss was gone.

I was getting married. My beautiful wife and I wanted to have a kid, but I was broke so a good friend of mine with connections in the commercial industry said, why don't you get into directing commercials, you have a great eye for camera and you'd be really good at it. A lot of the top filmmakers direct commercials while simultaneously directing movies. Everyone from Wes Anderson to Martin Scorsese is doing commercials. So I thought that's what I can do on the side too while I'm getting my next movie going. Of course, in retrospect, that assumption was, once again, a bit naive. Directing commercials is extremely competitive and time-consuming. You can't just do it "on the side," unless you're Marty or Wes, you've just won an Academy Award, and everyone is fighting to work with you.

So I walked into MJZ, which is one of the top commercial production companies. A lot of the best commercial directors in the world are there. My friend introduced me to the founder and Executive Producer, David Zander, and he graciously said after viewing my work, you're talented—then came the bitter truth—but commercials are a whole different animal from movies, and you're not going to get hired to do commercials unless you've already done commercials (or you've just won an Academy Award). Later, I understood why he was right: just because you can direct movies doesn't mean you can direct commercials, and just because you can direct commercials doesn't mean you can direct movies. It's a whole different genre. It's a story told in thirty seconds versus a story told in two hours. It's a completely different format with different criteria and a different set of rules.

But Zander liked me, and said, look, if you want you can stick around, learn the business, put a spec reel together, and then with a little luck you'll be able to go out and direct commercials. I was broke, and thankful that he offered me a job, so I worked in the vault, dubbing, editing show reels, and helping with post production for all the big guys like Spike Jonze, Fredrik Bond, Rocky Morton, Craig Gillespie, and Marcus Nispel, who are some of the top

OPPOSITE BELOW:
Cox Communication "Sidekick" (Swire/Buzzsaw, d. Bruce MacWilliams).

commercial directors in the world. I was watching all the dailies and rough cuts come in, and I was learning, every day, soaking it all in. After a year and a half, I put together my spec reel of four commercials that I wrote and directed, financed with credit cards, going broke, and calling in favors all over town. And because I was at MJZ I had access to a lot of top facilities for editing, sound, telecine, and camera rental, and that helped.

I wrote six or seven commercials scripts. Then I had lunch with David Zander and Craig Gillespie, a great director at MJZ who has won every major commercial directing award, and I showed the scripts to them. I was thrilled that they both really liked my writing. That was my background; I wrote both of my movies as well, and I had learned over the last year and a half at MJZ how to write commercials too. So I took the four best scripts and shot my spec reel. Todd Dos Reis, who had worked with me on my last feature film, and later ended up as the Director of Photography on the hit TV show *Entourage*, thankfully, agreed to shoot it for me.

The reel turned out very well. I was still working at MJZ in the vault, but at lunchtime I'd sneak out and show my finished commercials to all the top production companies. Everybody loved them, and I had several offers. I ended up going with Biscuit Filmworks, one of the best production companies, helmed by Noam Murro, who has won the coveted DGA Best Commercial Director award twice. And I gotta say, after I signed that contract I was doing backflips. There are very few directors that ever land in a top production company with only a spec reel. I had huge visions of grandeur.

And it did start off very well. In 2004, Saatchi and Saatchi recognized me in their New Directors Showcase, with two of my commercials playing second and third place at a big screening in Cannes. And *Shots Magazine* out of London, in their Grand Prix Award edition, ranked me the third best new director in the world. It was an extremely good launching pad. I was very excited. I felt like I had just won a bronze medal in the Olympics.

So you might expect me, now, a few years later, to be a superstar commercial director that works continuously, but I'm not, and I don't. I still work very hard to get each job. My only solace comes from my friends, who are at the top of the pyramid. I ran into Craig Gillespie recently, who as I said earlier is one of the top commercial directors in the world, and he confided in me, saying, "It never stops, it's always a struggle."

Getting the job is always extremely competitive, then the frustrating part about directing commercials is that not only must you have the great talent of Fredrik Bond, Dante, Craig, or Spike, you also need to have the great boards [scripts], and that comes down to the writing, which is out of your hands. You might have worked very hard to win the job, but the writing is not great. Directing a commercial without good boards is like trying to make a great movie with a bad screenplay—you can't do it, I don't care who you are. The same thing's true in commercials, if you don't have the boards it's impossible to make an amazing commercial. The top directors get the best scripts offered to them because their work is the best, and that cycle continues. The break for a director climbing up the ranks comes when a great script falls through the cracks (maybe because someone else for some reason didn't recognize its greatness) and you get a shot.

The Director and Preproduction

After you're signed by a production company, they are banking on you working a lot, which will in turn earn the company money. They'll have anywhere from five to twenty directors, and they try to sell them

OPPOSITE: Nike "Beach" (d. Bruce MacWilliams).

all. The production company will have reps who go out and sell your reel (and you as a director) to advertising agencies around the country, and around the world. In my case, they'll say, oh I know the perfect director for that spot, Bruce MacWilliams, and they'll use my reel to sell me.

Meanwhile the agencies are doing their own scouting, particularly now that the Internet is so prevalent, or they just go back to the same guys they've used before. Either way they'll usually end up with several directors who will bid for the job, each writing a treatment, adding visual references, and explaining how they would direct the spot. Plus, a producer from your company will come up with a budget for the commercial based on the boards, the particular agency's requirements, and the director's creative input. Most companies come very close to the same number after consulting with the agency when bidding, so usually the job goes to the director that the agency thinks will deliver the best finished commercial from their script.

When pitching for a job, I'll have made a visual treatment using my own photographs and other references from magazines, books, and the Internet. I will also write a detailed five-page treatment where I tell the agency exactly what I want to do to take their script and turn it into a masterpiece. Call me a bullshitter if you want, but truthfully, I always shoot for the stars. Creating the treatment can be a very elaborate process. You can spend two or three days putting it together and then not get the job. But it's good practice, it sharpens your visual skills, and sometimes it's a piece of art in itself. There are artists all along the chain, mostly at the ad agency, in the process of making a commercial, who have to come up with good creative ideas that'll many times never see the light of day.

Once the job has been awarded, the production team led by the producer will start working fast and hard on the logistics of putting together what basically is a little, one-to-three movie shoot, all in about ten days of pre-production. Pre-production for a commercial shoot is fast and furious, and it's impressive how quickly a film crew is assembled, shooting locations are scouted, and actors are cast.

In order to prepare for the shoot I do my own storyboards. On a really big commercial, I'll give them to a storyboard artist to make them look a bit sharper, but on smaller jobs I'll just do them myself. It helps me plan the right look to make the spot really sing. Even if the shoot is handheld, shot on the fly, full of spontaneous movement and dialog, I still like having boards to keep me on track with the script. Then in the preproduction meeting I take the agency through the storyboards shot by shot, so we can discuss exactly how it's going to look. It's important for us to all be on the same page before we shoot. Of course there is hopefully some unexpected magic that happens when we actually roll camera, and we want to adapt to capture the magic, but it's smart to have a plan to use as an initial starting point and to fall back on so you can stay on track.

Proper casting in commercials is critical. The right actor or actress can make a huge contribution to the success of a campaign. Sometimes commercial casting tends to be fashion oriented, in the sense that certain looks go in and out of fashion. A lot of times casting tends to pick the person who captures the feel of what people want right now in order to capture a certain demographic. In comedy spots, it was the Jack Black look for a long while, or sometimes the all-American version with sandy blond hair. In the last two years beards have been big. All guys have to dress like a hipster and have a beard. It goes in cycles. That's why when you watch commercials, particularly by the best directors, you see a lot of the same faces.

But, ultimately, actual acting talent is the most important factor.

You'd be surprised. Even for two lines, not anybody can do it; you have to have good actors. Some people can deliver and some people can't. I studied acting for two years at one of the top acting studios in L.A. with some amazing actors like Giovanni Ribisi and Jenna Elfman, because I knew if I wanted to be a top director I would have to know acting too, and the experience of stepping onto the stage or looking into a camera ended up giving me a huge respect for great acting.

To get a job acting in a commercial is extremely competitive. You've got thousands of people trying out for one spot, because they're going to make good money, and it is real acting. It's the same for directors. You get to play with all the best equipment, work with the best crews, and the best creative minds, all to create a little thirty-second movie that the whole country may watch. So it's exciting.

Post-Production

How involved the director gets in post-production really depends on the agency where the production is, and where the spot is being aired. I shot some commercials in London a few years back, and over there they like the director to be involved for the entirety of post. I cut the whole thing with a great editor, showed the agency the final cut, and they said yes, we love it, let's run with it. It was great; this was a huge, million-dollar commercial. In America, though, it depends on your relationship with the agency. With agencies here if I'm lucky, I'll often do the same thing: I'll direct it, make a cut with an editor, and show it to them and they'll say, yeah great, or maybe make a few little changes, and tweak it or whatever. It sometimes hurts when they start recutting your work, but honestly, most times we all agree, and it gets better.

I did a commercial once with an agency out of Chicago, and I was going right into directing another campaign in Miami, so the agency directed the edit. I could see cuts via the Internet, and I could say let's change this and that, and they'd usually do it, and then sometimes they'd change it back. I try to shoot a lot of coverage using different camera positions and focal lengths during the day, but there's a way it goes together, like a puzzle, to tell the story in the most effective way. A good editor can usually tell. These guys know what they're doing. The editors at the top editing shops in the world will probably come close to what you wanted anyway, or make it better.

Also you circle your favorite takes on the set. You tell your script supervisor and after checking the shooting notes, those are the ones the editors normally go for. They're not always going through and checking every last shot in the dailies. You give them your shooting notes and most of the time you get your own cut. I've never been in a situation where I've said, my God they've ruined my work. It does happen to some directors, but it hasn't to me.

The big choices are the music score, voiceover, and graphics, and I usually bring all those people in too. If the agency doesn't like my choices, we try another artist. It's like casting. But we all tend to agree. It's not rocket science, for example, to see who the best actor is for the commercial. There might be a little difference between two: if I feel I want to go one way I'll explain, and if the agency want to go another way, then you've got to wonder if they're right, because these people are smart too. But we do tend to agree, because everyone's working for the same goal: to make a great spot.

Art and Commerce

The truth is that even as successful as my spec reel was, as Craig Gillespie said when he saw it, try doing work that fresh and

original for a client. I didn't understand what he meant, but five years later I do. It's really hard to write cutting-edge creative, and then be able to sell it to the client. The agency struggles constantly with this, because they have a really hard time selling cutting-edge creative to Clorox or Chevron or whoever they're doing it for. Some companies embrace fresh, new ideas, but not all. Most companies have a certain demographic they're selling to and sometimes there's no place for the cutting-edge stories. That said, each year we do see some amazing work by excellent agencies and directors that managed to break all the rules, and everyone including the client is glad they did.

Luckily for me, the agencies I work with have been interested in pushing boundaries. The creatives at the agencies, the creative directors, copywriters, and art directors are some of the most creative people you'll ever meet. Something most people don't understand is that a lot of the creative elements you see in movies and TV are rehashed from stuff thought up for and tried out first in commercials. They also don't understand that a perfect commercial is a piece of major art. When you see the best commercials, they blow you away.

A Collaborative Process

Most of the agencies I work with have a lot of confidence in my work, and it feels like a team all headed in the same direction with the same goal. But sometimes when I'm directing, I have ten pairs of eyes in what we call "video village," several yards

BELOW: Fox Sports "Golf Wars" (spec commercial, d. Bruce Macwilliams).

away, watching monitors plugged with long cables directly into the camera, and they'll send a messenger over to me at camera, or sometimes come over themselves to deliver a note on how I might want to change something. So a lot of times I'll ask the agency creative director to come over and hang with me at the camera. It's a much more effective way to collaborate because it goes faster and we are not separated into camps.

Working on commercials has helped me as an artist because it really is uniquely collaborative. By the nature of the process, you are forced to collaborate, and if you fight it, you will only kill the project. Instead, I have learned to embrace collaboration. You're still directing, so you're usually still in charge, but getting the input from other artists on the set can be extremely valuable when you're working with other creative people that you respect. The creative directors, copywriters, and art directors of these top agencies are talented artists too, and my own crew: the cinematographer, gaffers, and production designers are great artists. When you collaborate in filmmaking you compound creativity in exponential ways. When you slip into synchronicity, the results become extremely powerful. Synergy like that is extremely exciting. Working with people you have mutual respect for is how you're able to manifest an incredible piece of work.

I've got a couple of different crews, depending on what the job is. Some of them are interchangeable depending on their availability; some of them I can't afford on a smaller job. My favorite DP, Arturo Smith, is a good friend of mine

ABOVE: Nike "Beach"
(d. Bruce MacWilliams).

who lives in Berlin, so on a lower budget job, I Skype him and say, Arturo, if you want to fly yourself in you can shoot it, and you'll be well paid for the days we shoot, but if not we'll go with someone else. So he crunches the numbers, and sometimes he'll do it. I always give him the option, but if the numbers are too low, and he can't make it, I'll use one of my other DPs. I believe in loyalty, and I always try to work with the same people that have worked hard for me in the past. It is a really tough business and it's good to build a network if you can.

It is good to work with the same people, whom you know are talented, and you collaborate well with. I can crew up with my favorite team, if they are available, in twenty-four hours. But it depends on what you're shooting. Sometimes you can't afford your favorite team. The top directors can use the top DPs in the world. Academy Award-winning DPs like Emmanuel Lubeski, Roger Deakins, and Bob Richardson all shoot a lot of commercials as well as beautiful movies. I'm confident with the camera—I've been shooting since I was fifteen, and I've shot plenty of commercials, docs, videos, and PSAs myself, but what the DP will do is make it look even better, bring a new creative eye to it. It is much better, if you can afford it, to hire a great cinematographer. You still get to direct the camera, but the collaboration will make it much stronger.

The Camera

As a director, or as a cinematographer, you use different tools, different lenses, for different jobs. I might shoot something with a Go Pro camera, which is a little throwaway plastic camera that costs $200, or I might shoot something with an Arri Alexa, which is a top of the line HD camera, or I might shoot something with an Arri 235, or I might go Panavision (which are both 35mm film), I usually chose Zeiss lenses, but sometimes I might use Cooke lenses—it all depends on what you're shooting, and the look you are trying to achieve. There are different looks, different tools, and different stories you want to tell. And also different budgets.

I'm a big Arri guy. I've used Arriflex cameras from my first movie all the way through, with Zeiss primes, and I still use that combination now if I can. But I do a lot of comedy spots, and now that the industry has made almost a complete shift to shooting HD, I'll do a take and I won't call "cut." I'll just keep directing as the camera is rolling, asking the actor to give me a new version. I don't want to have to stop and

"Ultimately . . . the biggest factor will always come down to the lighting, composition, movement, the DP, and how it's shot."

wait for reset, lighting, tweaks, make-up, and all the rest of it. I want to keep it going because it's really valuable time, and with digital you can do that, because there are no production costs. Film is expensive, and the processing and transfer costs increase that cost exponentially.

My favorite camera right now is the [Arri] Alexa. The Red Epic is a great camera too. The different cameras give a slightly different look. It's like choosing film stock. If you choose 5218 Vision2 Kodak film, it has a certain look to it, and if you know your film stocks you know what it looks like. Fuji film stock, for example, is a different look which is usually much warmer. The same is true of digital camera sensors. They each give a different look when capture is initially completed. In most top HD cameras the resolution is so fine you can't tell the difference now, but they do inherently have their own look. The Red One I equate to the Fuji look—it's softer, with warmer colors— whereas the Alexa is a little lighter, more desaturated. In post-production of course you can change the look captured by any of these cameras to make it anything you like. But I believe it is better to capture the desired look initially, if possible, instead of changing it in post. Ultimately, though, it doesn't matter what camera, HD, or film stock it is shot on—the biggest factor will

always come down to the lighting, composition, movement, the DP, and how it's shot.

Now there's a whole set of new less-expensive HD cameras coming out, like the Canon 300 and the Black Magic. It's exciting for DPs, operators, and directors, who want to own their own camera and shoot a lot. The Black Magic costs about $3,000 and it shoots 4K. It's made by the guys who designed the Da Vinci Resolve [color correction software and hardware]. It's a pretty incredible camera. Of course the most important factor (from a technical standpoint) is what lens you are using, and a good lens is expensive. If you've got a below-par lens it doesn't matter how big your sensor is. It'll still look bad. But again, neither the camera nor even the lens make the shot; the DP and the Director do.

BRUCE MACWILLIAMS

Tesco supermarket/ Cherokee clothing

I got a call from my rep for Europe saying, we've got someone over at the Lowe's agency in London who really likes your reel and particularly likes your "Golf Wars" spot. They'd like you to bid for a Tesco Cherokee job. It was Tesco (like Target in London) with Cherokee clothing—a dual ad. It sounded exciting. This was a big commercial. In fact, it was going to be the biggest commercial Lowe's would do that year—a million-dollar spot.

So I joined a conference call and talked with the agency, wrote a treatment, constructed a visual treatment, and sent it to them. I was in fierce competition with four or five other directors doing the same thing, and the agency had to decide who'd get the job.

They sent the script, describing a hip-hop pool party with a beautiful crowd, all wearing Cherokee clothing—a kind of perfect kind of mixture of hip hop and something more preppy (similar to Gap and J. Crew). They wanted to give the preppy look a bit of an edge, and I was perfect for it because I'm kind of preppy with a bit of an edge myself. I spent four years in prep school outside of Boston (Andover) so I've got preppy in my blood, but I've also done a lot of volunteer mentoring work over the past ten years down in South Central, L.A., a grassroots organization I still help run, called LA City Camp, that's been successful. The good news for me was it ended up giving preppy me the gangster edge I needed.

At the time, I'd just been voted the third best new commercial director in the world at the Cannes Film Festival by *Shots Magazine* in their annual Grand Prix edition. But I wasn't the top director in the world, I was still new to commercials, and I was bidding against some of the best directors in the world. I knew they had me outgunned, but I beat them because they didn't know "preppy meets hip hop," and I do. I knew hip-hop artists from South Central and Compton, and I brought in this one friend, Nune, to be the star of the show. Nune definitely brought the gangster edge to the spot. He's the real deal, a very talented gangster rapper from Compton. He was going to be able to use his own music and bring the swag, the real swag.

The creatives at the agency loved it, but the problem was they had to sell me as the director (and the way I proposed to direct the commercial) to the client, Tesco. Tesco was worried about shareholders, and their image, and they couldn't be associated with gang-banging. Hip hop is okay, but gangster rap was pushing their boundaries, and Nune is all gangster rap. He's a friend and a great artist so I pushed for him, but they pushed back. They

wanted more preppy, less gangster so we couldn't use him, but he ended up happy because they had signed an agreement, and they honored the payment.

So I still got the job. The shoot was in Miami but the preproduction was in London, so they flew me straight from a job I was doing in L.A. to London, first-class (that's a DGA requirement for international flights). I was picked up by a Mercedes limousine and dropped off at the très chic St James Hotel. I felt like a king. A year before I'd been dubbing videos in the vault at MJZ.

Preproduction was three days. First the big boardroom meeting, where I showed the Beyoncé "Crazy in Love" video as a visual reference to the client suits, the agency creatives, and my London producer. Then I projected pictures of the Miami location scouting I'd had done for me, and talked them shot by shot through my storyboards. Basically, I was putting on a show for twelve people who could fire me at any second. They had forked out for an expensive plane ticket to London, but they could fire me right then if I didn't impress them, and there was a lot of money on the line—one million dollars plus the agency's Tesco account, worth millions more—so I really had to deliver.

I had prepped this job while I was shooting a Wrigley's gum job in L.A.,

with location scouts in Miami sending me shots. I was picking out a Miami crew, and a myriad of other details. I had flown from L.A. to London on the red-eye and so ended up doing the presentation on no sleep, with a fast preparation. But I got lucky, and knocked the ball out of the park. I hit them with so much enthusiasm and adrenaline-induced energy that the senior agency producer, one of the top guys at Lowe's, said it was one of the best pre-pros he'd ever had. That was the best compliment I ever received. I was thrilled.

I told them we should go for a visual look like the Beyoncé video, and I said I would bring in my DP from Berlin, Arturo Smith, but they said if you want that look, we should probably get the DP who shot the video. I was confident Arturo and I could get the look, but I was outvoted. It's a great video, and shot really well, so we brought Mark Plummer on board, a big English DP who shot the "Crazy in Love" video. He's shot a lot of great commercials so we felt we were in good hands.

We flew from London to Miami, my producer flew in from L.A., and all the preproduction was finalized. That was one week, and then we had a three-day shoot, or rather three nights (and actually we lost one to rain, so it was four nights). Then we would fly back to London for the post. My son was five at the time, and I

ABOVE: Tesco's/Cherokee "Pool Party" (Lowe/Biscuit, d. Bruce MacWilliams).

told them I couldn't leave him for a month at that age, it would be too traumatic for the little guy (really, it would be too traumatic for me!). I told them they had to fly me back to L.A. for the weekend after shooting in Miami before returning to London to direct the post, and they did. I was feeling kind of cocky, and I know that was pushing it, but I was glad, because it made a big difference to me and my boy. That's one problem with directing—you travel a lot, and sometimes you miss your family.

So, we're in Miami and are being treated like kings, staying in the Shore Hotel, which is quite the scene with Colombian drug dealer types doing the Scarface thing, and models hanging out topless by the pool. We were having very expensive sushi dinners at Nobu, and I was thinking, holy mackerel, this is fun, but I could shoot a movie for what this is costing. And it was just four days of shooting. Two spots, or rather two different versions of the same spot, for a million dollars. But I couldn't complain, it was too much fun. I was shooting with a crane, Steadicam, tons of lights, and 150 extras. We were putting a party together, with all the hip hop guys and every pretty girl in town (and there are a lot of pretty girls in Miami).

The DP, Mark Plummer, whom I'd never met before, was a little nervous because basically he'd double-booked, or his agent had double-booked him, and he had a big BMW commercial right after. On the first night, after a big rain storm had pushed our shooting schedule, he told my producer he wasn't going to be there for the third night. All of a sudden, I'm losing my DP, which could put the whole shoot into a tailspin.

Incredibly, my favorite DP Arturo Smith (who works out of Berlin) called me up out of the blue and said, hey Bruce man, what are you doing? And I said, I'm in on this huge commercial, that I tried to

hire you for but they wouldn't let me, and I'm bummed because my DP has to leave; I didn't want to use him, I wanted to use you, and now the whole job is about to fall apart, and I am freaking out. Arturo was like, I'm in Miami right now! Serendipitously, he had flown in from Berlin to shoot a music video, which he had finished that morning. I was floored. What synchronicity! The film Gods definitely threw me a bone on that one.

I went to the agency and said, bad news is we lost Mark Plummer (the guy you wanted); good news is we got someone better (the one I originally wanted). Mark felt bad he was ditching us, so he left his gaffer, and his gaffer's really good so the lighting was consistent, and he lit it beautifully. We had this great, huge, modern, Corbusier-type house, and a big beautiful pool we built a large set around. I had a lot of guys breakdancing, spinning, beautiful girls dancing in sync, and a stunning half-naked girl slowly coming out of the pool. We lit the bottom of the pool, and the tracking shot, combined with a Steadicam wraparound shot, looked fantastic.

One thing we wanted from the Beyoncé video is what I call the "pulling frames" trick. It's harder to do than it looks. One of the editors I used was one of the guys who pioneered the trick, a rock-and-roll and hip-hop guy who did music videos. Danny Boyle did it in *Trainspotting*. I saw it used in *Premium Rush* recently and it almost feels dated now, but back then it was cutting edge.

I'd sold the agency on that look, then I had to go figure out how to do it; ironically, Mark didn't know either, because the editor and the director on the "Crazy in Love" video were the ones that created it in post. So I had to figure it out. The editor is one camp, and the DP is another, but the director has to be in both. So after talking to the editor to find out what he needed, I knew what Mark

RIGHT: Preparatory material including brief, casting sheets, location photographs, and storyboards, for Tesco's/ Cherokee "Pool Party" (Lowe/Biscuit, d. Bruce MacWilliams).

TV page 1

client	TESCO	TITLE	POOL PARTY
product	CHEROKEE SPRING '04	date	08/01/04
job number		length	40 SECS

Audio/video

[This commercial would take place at a Miami style pool party at night. The whole feed of the ad would be that of a R'n'B/Hip Hop type video; Think Beyonce's 'Crazy in Love'. We would use all the same kind of techniques, sexy slow motion, cool cutting etc and beautiful saturated colouring to give the impression that this is a genuine promo]

MUSIC: A bang up to the minute R'n'B/Hip-Hop track.

We open on a super cool Miami pool party. Pastel coloured lights are illuminating the fantastic Art Deco building. Attending the party are some very cool people, including the rapper whose song it is. We see him entering the party with a real swagger followed by his entourage. He's singing to camera.

Inside, the party is in full swing with everyone dancing around the pool and a large DJ spinning the tunes. We see a few sexy girls dancing seductively and some cool dudes looking over flirtatiously.

We cut to an attractive girl pulling herself up out of the pool in sexy slow motion. Suddenly, a 'starburst' pops up by her side, which reads: BIKINI £12. The girl quickly grabs it and plunges back into the water, her eyes just peeking above the surface as she holds the bubbling 'starburst' out of sight.

We follow the rapper as he struts past three girls pulling off some choreographed dance moves together. As they shake their butts a 'starburst' appears by one of the girls, which reads: SKIRT £15. The girl uses her bum to bounce the 'starburst' out of fame and over to a guy break-dancing.

As it bumps into his side it changes type like a cash register, it reads: COMBATS £20. The guy quickly grabs the 'starburst' and uses it as a mat as he goes into a head spin. He looks around, upside down, to check that none of the onlookers have noticed.

We cut to the large DJ behind his console surrounded by groupies, but he moves aside as the rapper takes over the control of the desks. Suddenly a 'starburst' appears by his side, which reads: T-SHIRT £8. He quickly looks around before grabbing it and spinning it like a record before slapping it down on once of the decks. He tries to cover it up further by bringing down the needle on the record and 'scratching' with it. The music comes to a crunching halt as the needle, and the party, are ruined. The rapper looks very sheepish and smiles nervously as the entire party look around to see what has happened.

Super: DESIGNED BY CHEROKEE. Followed by a 'starburst': PRICE BY TESCO.

CHEROKEE | JOB# 2004-04

Wednesday, February 25th 2004
Thursday, February 26th 2004

"POOL PARTY"

RAPPER

Lawrence Whiting
804.304.0361 cell
805.532.0034 agt/Talent Group

POOL GIRL

Jennifer Dias
805.753.8942 cell
805.474.7298 h
805.532.0034 agt/xYG

RAPPER POSSE

Ahjad
805.445.3732 cell
805.485.7451 hm
805.532.0034 agt/

DJ

Joancarlo Johnson
914.822.7147 cell
805.532.0034 agt / Ty Sum

(later Arturo), and I had to shoot to make it work.

The other effect was to have the various Cherokee clothes price tags pop into the shot magically. It was, look how smart we are, we look great, but we're only spending £10.00. It was a gag that was already in the previous campaign, in ads done before me. I didn't really like it—I thought it was kind of cheesy—but they had to carry it on. In order to shoot it correctly, you have to lock off everything, and keep it in exactly the same place for both shots. You're creating a composite shot, so you shoot one plate with the actor there, and then shoot exactly the same shot with a price tag held on a C-stand right next to the person, and then you rotoscope out the C-stand in post, and cut the two shots together, so in the finished spot the price tag magically appears. I already knew how to do this, but the agency was nervous, so they brought a guy in from the Mill [London post house], a special effects editor, to watch to make sure that it was all done

ABOVE: Preparatory materials for Tesco/Cherokee shoot.

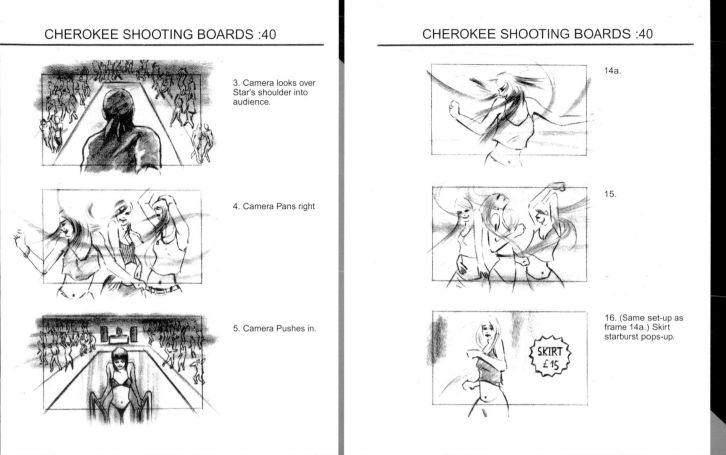

3. Camera looks over Star's shoulder into audience.

4. Camera Pans right

5. Camera Pushes in.

14a.

15.

16. (Same set-up as frame 14a.) Skirt starburst pops-up.

SKIRT £15

properly. To fly him down, to put him up at the Shore, feed him, that probably cost the agency fifteen or twenty grand, just for him to watch to make sure that that one effect was done right. And I knew how to do it already. I just said, okay sure, no problem. And all he did was sit there eating craft services all day and hanging out. He was a cool guy, and was probably loving the vacation in Miami.

They were long nights. It was a huge party, but it was a controlled party—I had to keep my eye on everything. There was a wardrobe girl and I knew from the beginning we didn't get along, but I'm easygoing and can usually get along with everybody, so I went along with her. She was one of these people who have this neurotic need to have their job be the most important thing on the set, and it's just not. Yes, wardrobe is important, but the wardrobe should not control the entire shoot. I do care, the shoes have to be right and so forth, but she was driving me crazy. I told her specifically, because of the special effects we are trying to

ABOVE: Storyboards for Tesco/Cherokee shoot.

create, this is a locked-down set, which means I've approved everything, every shirt, every dress, every pair of jeans, on 150 people. You can't change anything. I like this look, the creatives like this look. This is what they're going for. We had those plates to shoot and you can't have things changing in between them, or it will look in the finished spot that a pair of shoes magically changed color. But sure enough she changed a pair of shoes. I found out later in the shoot, luckily before we got to post, and we had to reshoot the entire scene, costing us hours of work. People say, oh just CGI it, but that's super expensive. The rotoscope is $1,000 an hour. You can't just say we'll fix it in post.

Anyway, I lost it. I just yelled at her. It was four in the morning, and it had been raining, and we were pushed, worried about having enough darkness before the sun rose, and the Mark Plummer thing had gone down, so I just yelled at her in front of everybody. It's the only time in twenty years of directing that I've ever yelled at anyone on set, and I learned

my lesson that it feels terrible, and it is not a smart thing to do. I did it in front of everybody, yelling what the hell did you do? right across the pool. Some directors do that every second, even some of the top directors in the world, but it's just not my style. I always treat everyone with respect, right down to the personal assistant (PA). I'm known for that. But this girl had just been doing it over and over again, and I just blew up.

So I looked like the bad guy, yelling at this girl, because no one else knows the back story, and this is not my crew, apart from Arturo and my producer. They're all Miami crew—production manager, location scouts, first AD, and so on. So the crew went silent and I thought, oh no I've lost my crew. You don't want to do that on a set. It'll kill the shoot. So I apologized to her in front of everybody, and we went back to the party again. But I learned my lesson. If someone isn't working well with you in preproduction, get rid of them before you step on the set to shoot. It's like trying to hide a stick of dynamite in the back seat of your car as you're

ABOVE: Tesco's/Cherokee "Pool Party" (Lowe/Biscuit, d. Bruce MacWilliams).

"The scary part is waiting for the lab report that the film negative looks good."

driving to go surfing after the fuse is already lit; no matter how good the waves are, you're not going to be there to enjoy it!

I spent ten days in London directing the edit. I camped out in the edit suite, finished a cut, and gave it to the agency. Thankfully there were no real problems. The dailies looked amazing, as they should: you're watching the monitor while you shoot and choosing the takes, giving notes to the script supervisor; everything's storyboarded out very carefully, so I know every shot I want; and I won't stop until I get it. We were shooting super 35mm film so the only scary part is waiting for the lab report to come through so you can hear that the film negative looks good. Without that, you're in trouble. But the news was good. The editors that I was working with we're really great, and the cut looked great.

The whole schedule was two weeks pitching the job—getting the crew, doing the research—three or four days in London and ten days preproduction in Miami, with all the casting, the final location

scouting, and wardrobe. The shoot's always the shortest component, which in this case was four. Then ten days in London—about month and a half all in all and then boom, it's on the air broadcast all over the UK. The reaction was great. The agency loved it. The client loved it.

Personally, when I look at that commercial now, it's a good commercial, but it's not great. It's not even on my reel. The irony is that one of the best ones on my reel is the one where I went down to South Central and shot a great little spot for Fox Sports for no money, and this million-dollar Cherokee commercial isn't currently even on there. It's not how much you money you spend on it, or how much fancy filmmaking gear or clever editing tricks you use; ultimately, it all comes down to the script, the story. In this case, it just wasn't that interesting. But the story of the making it was a blast. We all had a blast. Even the wardrobe girl ended up having a blast.

Arturo Smith: Cinematographer

Arturo Smith is a cinematographer whose credits include numerous award-winning features, documentaries, advertisements, and music videos for The Beastie Boys, Prince, NWA, and Marilyn Manson among others.

"Cameras are so cheap now you can really develop and learn by yourself."

Starting out

I started out in the early nineties, working on movies and commercials. I used to work for two really big camera guys at the time, and two really big directors. It was a transitional time. A lot of the trade of the cinematographer is exchange. You assist somebody, normally, apprentice to someone really good or really famous, and they probably learned the same way. It's very rare to come straight out of school and become a big cinematographer, unless there was a big director at the same school at the same time—teams become famous together, etc. But it's more like learning how to do it from somebody, sort of like a carpenter's trade.

Things are a little different these days from when I started. I always tell people to go out and do it themselves and experiment, and get themselves on some sort of working crew of people so you can see how the other guys work. There are so many cameras that are so cheap now that you can really develop and learn by yourself, and try to get a job. Here's the problem though: when I first started I lived in L.A. on the beach, and there was a community of working people—I mean half the city lives off the film industry. So it was really easy to get a job, and it was really easy to learn the trade, because there were so many crews working. And then of course there was the huge explosion of MTV right at the beginning of the nineties. Thousands of commercials, thousands of music videos, and hundreds of movies were being made every year, but that community no longer exists. Out of the twenty-two big television shows that'll be signed off by the networks in the U.S., not many more than one will be done in Los Angeles. The other twenty-one will be shot God knows where. You don't have a community anymore; it was really easy to find a job when I started that way, but now I would say you just have to start working on your own and find a crew you can join.

OPPOSITE & BELOW:
Greek Nikon ad
(DoP. Arturo Smith).

Working on Ads

It depends on the year how many commercials I shoot. For instance this year [2012] I'd say has been mostly commercials. In other years there have been more film projects, but they can absorb a large portion of your year, because they take that much longer. I also do documentaries on occasion, but I haven't done one for a couple of years. Commercials are the most lucrative, but it also has to do with the fact that films are so few and far between these days.

I live in Berlin now. It's the second time I've lived in Berlin, and I've been here about two and a half years now. The first time I came here I started a company to do what you could call commercial work, but it's not quite advertising in the standard sense. It's more to be associated with larger companies and do image projects for them —special types of design, like 3D stuff, exclusively for certain clients.

Using new techniques on advertisements you get something instantly, an instant gratification, but once you've learned it you move on. You learn more on some than on others, but that's mostly what I get from ads. And then just the fact that you work with people that you know, and you care for, and the team that you work with. It's more about the camaraderie for me than the actual finished project, because the life that a commercial has is just so temporal, in my opinion anyway. I've never seen a lot of finished ads that I've worked on. After it's done, I'm on to the next thing.

Working All Over the World

Recently I've been working in many more countries. In the past four months I've worked in Romania, I've worked in Russia, I've worked in Dubai, I've worked in India, and I've worked in Germany, of course. In all these places, you could say that the ad companies have somewhat the same philosophy. Execution might be a little different—in quality perhaps, although not very much. It seems that the markets in terms of quality are balancing out, because of the digital technology, because of the people who are hired. I do jobs where you call people of international level. So normally I go in with directors from all over the world, primarily Europeans, who tend to range more around the world, and then we use the people who are there in the location country. But the message that we're sending normally has some of the same sorts of corporate directives; the higher level agency people tend to rotate quite a lot around the world—you see them in Dubai, you see them in London. The creatives rotate.

It's different in every place, but it's fun. It's the job. One thing I'm attracted by is the locations. There's a Russian job right now that they want to shoot in Rajasthan. It's Lipton's Tea, so it's probably a British agency. That of course goes up in my priority list as to what I want to do this month. And of course the people that you're working with, the directors you're working with; although they too tend to rotate quite often these days. I think directors' lives are so much shorter than they used to be in years gone by. There's a new pool of directors every five years, I find.

It's a little freer in most countries now, at what point I'll be brought in on a project, and how much input I have. For instance in the States there's a storyboard, and your input is necessary only for the shooting. So depending on the director, you come in at a very late stage, and you shoot what has been demanded from you, from the storyboard. In other parts of the world directors have a higher input, so then I have a higher input too because I'm consulted much earlier. In some countries they just give you a small outline of what

ABOVE: Farmatado "Tint" (DoP. Arturo Smith).

you want to do and they put a couple of frames there, but it's not a strict guide. So the process of creativity starts earlier in other parts of the world. I don't know why—it certainly seems that the places where advertising has been around longer you have less of an input. And then of course it depends on the agency also. Some agencies are far more open for input than others.

It's a little more precise in America. Agencies are very, very exact about what they want from their storyboard. The material goes straight to the agency, in New York or Chicago say, and they decide how to play it out—directors don't edit any more in the States. In other parts of the world, directors work on the edit and have a stronger input throughout the whole process. In fact on the larger projects you have an input with the client from an even earlier stage. If you're going to do something more experimental, then the input starts earlier and lasts longer, and it's all more collaborative.

Expensive Equipment

Because so much money is spent on commercials it tends to be true that you get more and better equipment on advertising shoots than on features. But it depends on the features. There's always the latest toys, the latest technology. And then of course all commercials have different looks, so as a general rule you really learn quite a lot of your trade by shooting commercials.

I'm not really particular about cameras. The first time I came to Germany I was brought to shoot the first digital film in Germany [*Rave MacBeth* (2001)]. There were three prototypes of the Sony camera in Europe at that time—six prototypes in the world—so I started the digital thing really early. Nowadays I don't know—it just depends on what you've got on hand. Of course the Alexa is the machine of choice right now, but that tends to change very rapidly these days. Cameras also are perhaps the one thing that's really experienced a revolution in the last ten years. Special effects have really had very little change. Perhaps water, liquids, and hair stuff are the last things that came out

in CGI in the last decade. Whereas cameras over the last decade have evolved at a revolutionary pace. It's been really exciting for cameras this last seven or eight years.

The new Black Magic camera, for example, looks very nice and it has a very good price, but the thing that makes it less desirable to me is that a smaller chip implies a much greater depth of field, so then everything is sharp, and there's less play. See that's the beauty of say 35mm or a bigger camera with a bigger sensor: you've got so many more pictorial layers. You can play with the depth of field, sharpness, etc. Those kinds of things really make a hell of a difference. So cameras like the Black Magic are good for certain applications, and it has a great price, but it's not going to compete against the Alexa or the Red Epic. That's never going to happen. It's different, and aimed more at the prosumer, like the [Canon] 5D market, or that new EOS 300D. They seem suited more for documentaries, a little bit, and not for the high-end work.

As to lenses, at the film level they're so expensive already. One lens is $25,000—that's the equivalent of ten of those kinds of cameras for starters. At that level the optics are quite similar, so again it depends on the job. I may favor Cooke S5s for certain reasons—if the shoot is at that sort of level and you can afford them, of course. So it depends, and sometimes you feel like you want the flares of one lens, or the blooming of the light is a little different. Zeiss lenses and Cookes, which are the top of the line, just have different responses. It becomes an aesthetic thing in the end, like, oh I'm going to use the S4s today because I'd really like the highlights to come out this way or whatever.

Technological Advances

Of course we're also going to see major revolutions in lens technology. There's already the flat lens, or liquid crystal lenses. They're not available for the commercial world yet, but the designs are finished. Some of the liquid crystals can actually bend. This is way out there in research, but there's one particular professor at a university in Florida who's actually developed most of the liquid crystal lensing technology. His lenses can travel with light, or laser beams, and they can bend—you can see what's behind you. It's crazy.

And then of course there's a huge important development in what's called femto-photography. It's a small field, but femto-photography has already been able to record at a trillionth of a second. In TED [Technology, Entertainment, Design—ted.com] there's a little sample of what these new cameras are going to do. What this same professor showed at the TED conference was actual light traveling through a Coca-Cola bottle, which is amazing to see. They show it from the moment the beam of light hits the bottle, and then moving through. That means the camera is recording at far faster than the speed of light. It's amazing what's happening out there right now. Big things.

I wouldn't say that one gets to experiment more on advertisements, but on occasion it is possible. For instance I'm working on something right now which is a 3D project, but it's a little different. Standard 3D is essentially two images that are just off from one another—the same exact image—and then there's a convergence with the lenses for your eyes, like a ViewMaster. This is what we have in the commercial movies. But the original principle of projection was that these images, if they occur within a tenth of a second, then you feel like it's a continuous image. Now, if you have an image in one

eye, and a different image in the other, and you send them at the same speed, then you have a very different form of 3D. There's a very slight time lapse between them, and this of course can be manipulated in post, so you can actually either interpolate or extrapolate frames to suit the application. But you can only do this sort of thing for a really big client, who has someone who really wants you to do something like this. A new dude in town came into the office and decided, oh we're going to do something revolutionary, but he works for somebody who actually has the money to pay for this.

Trends, Traditions, and The Future

I think it's probably true for certain companies in Europe that they have been making different types of commercials from the traditional TV spot. I don't see that happening in the U.S. so much, or not to my knowledge, and I think part of it has to do with the fact that some companies here like to see more advanced imaging, a little beyond the standard of the thirty-second spot, or their standard stock-meeting presentation thing. They will take certain chances with certain things. Audi, Mercedes, Siemens, they're all well known for liking a little more risky imaging for their company. These don't necessarily have to go to TV. Sometimes they're just for their particular clients, or they also present them in forms which you can see for instance in large airports, like in Germany where you have these large moving screens. There are many places where they're displayed.

There are a lot of changes in advertising because of course there's so many trends that come in and out. For instance, I remember when I first started, ads were selling a different lifestyle. Luxury was the hot item back in that moment [early 90s]. Then there were

periods when comedy kicked back in. Comedy has been strong for a while. And then of course there's looks. There's always this thing about the "look." So many ads in a certain period have a particular look, like for the last five years now, there's been this desaturated, very plain, white look, especially in American commercials. Particularly in cosmetics— just the hair and the white look of it, you know, the white walls. It's amazing how much it's affected everything, to the point where, from the commercial, the art direction goes out into the stores now, so you get the same look in the store in a different form.

So there are all these looks, but when I work I prefer it to be a case-by-case consideration. You've done so many different forms of lighting that you can say, okay what do you want? You want it horror story or you want a Saturday Night Live look, or you want a reality TV show look, or you want science fiction? It just depends. All the looks are there, but I don't know if film really came up with these looks. It's all there from the painting days—that's all you really look at it in the end, all the great master painters, and that's essentially where you get your best looks from anyway.

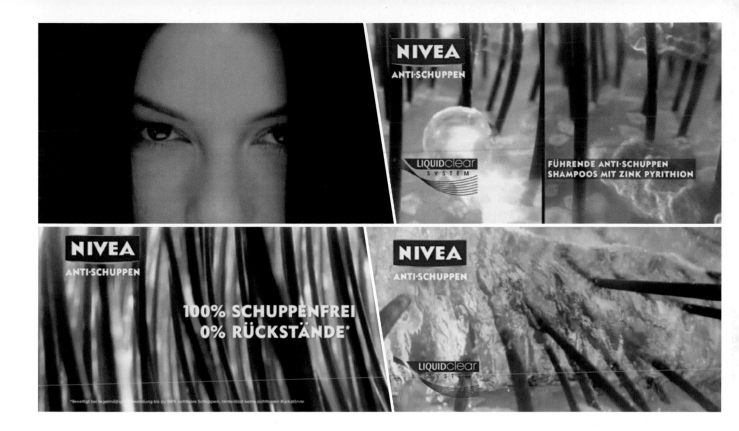

"You can say, okay what do you want? You want it horror story or you want a Saturday Night Live look?"

Ben Seresin:
Director of Photography

Working his way up from electrician via camera assistant in his native New Zealand, Ben Seresin has worked as Director of Photography on numerous award-winning advertisements, including spots for Guinness, Adidas, and Levi's with some of the world's most respected commercials directors, as well as lensing such high-profile Hollywood films as Tony Scott's *Unstoppable* and *Transformers: Revenge of the Fallen*.

Starting out

I developed a real interest in acting in high school and was in a few productions. When I left, it was initially to go to drama school, but one of the first jobs I got out of high school was in a production company as a general assistant—a great company in New Zealand called InterFilms. It was a tiny production company, at a time when the commercial industry was still very, very small in New Zealand. But in the smaller industries around the world you tend to get a much broader experience, much more exposure to the various aspects of filmmaking, even if you know very little.

Quite quickly I realized that as much as I loved acting, I was equally interested in the general production of films, how they were put together and the creative side of it. Pretty quickly I developed an interest in the camera department and the photographic side of commercial-making. New Zealand being New Zealand, and there being I think three production companies in Wellington at that time, the progress was pretty quick, although the standards weren't high; I went from being a general office boy to camera assistant within two or three jobs, knowing absolutely nothing whatsoever about the equipment, photography, or working within a crew. But that didn't seem to be a hindrance.

After a few months being on commercials I got the chance to work on a movie being made in New Zealand. Again, there were various jobs available to various people, and although the expertise wasn't high, the opportunities were tremendous. So I got onto this very big Australian production, being shot in Queenstown, as the seventh electrician or something. I was still desperately keen to get into the camera department, so I'd spend every spare minute on that film hanging out with the camera guys, much to the frustration of the gaffer on the job. Midway through the film, when they'd finished shooting interiors, they didn't need as many electricians, but they did need more camera crew for the exteriors. I managed to slot into that, as a clapper loader. That really got me started: I went from there and worked on crews in New Zealand, then met a camera crew from Australia who invited me over to work with them, and I lived in Australia for four years, working on films and commercials as an assistant. I'm based in the UK, but I work mainly in the U.S. I'm in the process of moving over to the States, which will coincide perfectly with the movie industry coming back to England. I've lived in England for most of my adult life, but in the last ten years or so, I've worked more in the States than here. I used to do commercials much more, and the odd independent film, but about four or five years ago I switched the other way and started doing bigger films as main unit Director of Photography, and they tend to take up most your time. I'll do maybe one or two commercials a year now.

Creative Vision

There are huge differences between movies and commercials, and this is a lot of what's pulled me more into movies. When I started as a cinematographer in commercials, the structure of the industry was very different: there was a lot more opportunity for developing the whole creative aspect of the commercial with the director, more opportunity to be involved earlier, and stylistically develop the look and the approach early on, which is really what it's all about for me. I was very fortunate to start working in those days, when you'd have a lot of prep and a lot of discussion, and it was really that the director's vision and input from his team would drive a big part of the creative brief on a commercial. It's very different these days.

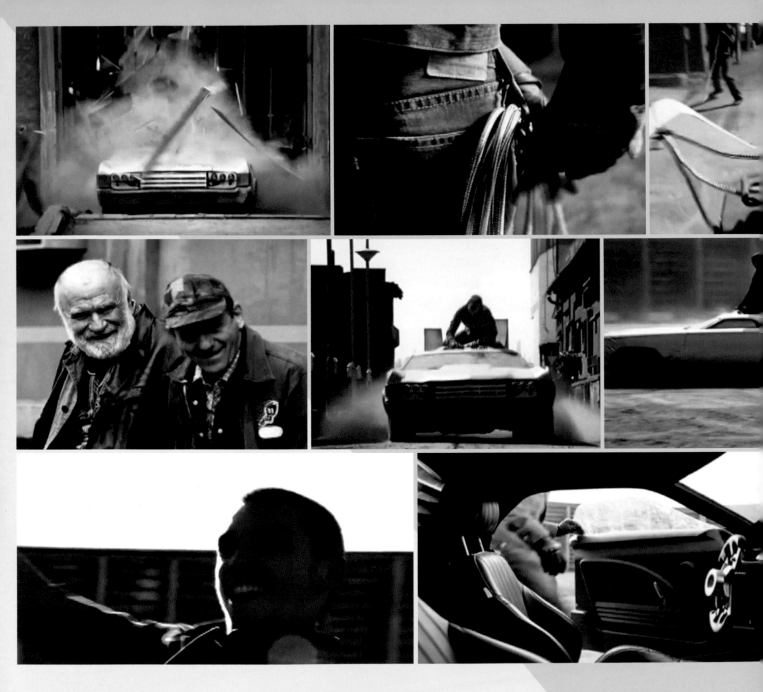

"It's so easy to recreate
what's been done . . . What's
interesting is what hasn't
been done."

I'm very much an advocate of the auteur theory, that there's one person who ultimately has the creative vision, who is the director. The best work, to my mind, whether it's a commercial or a movie, comes first from a great idea, carried out through the imagination, the eyes, and the mind of the director, and a strong supporting team. I don't subscribe to committee filmmaking in any way. There definitely are commercials where that development of a personal vision can be possible, but in the current climate, a lot of the general approach on commercials tends to be locked down quite early, and because budgets are being squeezed more and more, there's pressure to bring on key crew like cinematographers much later.

Unless you're on a big job, you'll often have frustratingly little prep time. Looking at locations with the director, and deciding on the look—those discussions are really important. The nature of the creative process on commercials is that these discussions take place much earlier than on films, often involving the client and the agency, and possibly even before the director's got involved. In my limited experience, in the last few years, and this is much more in the States than the UK, it seems that the creative brief is much more refined by the time the director gets hold of it, and often—not always, but often— there seems to be much less flexibility in the approach. That's something that's surprised me more and more, the more commercials I've done.

Happily there are great exceptions to the rule, and the really great creatives tend to be more open, and will still hire directors with great vision—that side of it continues. But the agencies are under more and more pressure to evolve a creative style and approach very early in the process, as part of what they're presenting to the client. The client will often want hard and firm answers in all sorts of creative areas that are often better

OPPOSITE: Levi's "Car" (BBH/Traktor, DoP. Ben Seresin).

answered down the track, once there's been an opportunity for discussion and evolution in that process.

More and more movies are following the path of commercials now. The studios, because of financial pressure on them to deliver results, are more and more tending to produce something akin to a guaranteed product. As soon as you're under that sort of pressure, your opportunity for experimentation and new ideas is lessened hugely. There's a handful of filmmakers still out there battling, thank God, and thank God that those films and those commercials tend to be the ones that are real eye-openers and connect with people.

Money's tight, ideas are researched to death; there's very little room for happy accidents or innovation on the day. What I love about the industry and my job is the magic that can happen when you go off in a creative direction, and can seize the opportunities that arrive. It sounds a bit hit or miss, but it's that elusive, magical quality that comes from filmmaking. The directors that I really admire will make that their mission in the process. It's so easy to recreate what's been done, by oneself or by other people. That's the safe way, and unfortunately there's often a lot of pressure to do that. But what's interesting is what hasn't been done. That for me is the whole idea, whether it's a film or a commercial.

Shooting

The whole structure of a commercial shoot is very specifically worked out, down to individual frames. Again often because of budgetary constraints, the opportunity to shoot extra stuff is just not there. Something like the Levi's "Car" ad actually had a fairly clear, linear narrative, and most of those angles were story-boarded, at least to give an idea of what was required from the shot. Once you get

on set, that evolves somewhat, when you seek out the most creative way of achieving that, but it's very unusual that you'd shoot a lot of extra stuff and then just cherry-pick the best. You don't have that luxury, really, or certainly not on the commercials I've done. I know some are done in a more documentary style now, where the subject's just hosed down, for want of a better word, and then they pick the best moments. But it doesn't generally produce great results, and I don't think the evolution of that sort of thing is particularly interesting.

Photographically I like very natural lighting and real situations. I tend to like things—and I try to keep this in my work—with a voice of authenticity and integrity and honesty. There's magic in simplicity, and it may be that it's actually quite complex to achieve, but if the results have a quality of simplicity about them, that for me is the most interesting thing. The work I've done recently tends—hopefully—to have something of that quality.

That said, the directors I like to work with tend to have quite a broad range, and that's also really interesting. On commercials, it's really more about the people: I'll be asked to work with people I know and have worked with in the past. Those relationships are so important, because you develop a shorthand, and when you can spark off someone else creatively, that's the magical side of it. That's really what I love about my job— a great collaborative job with the director and the production designer is what's really fun, being able to bounce ideas off other people and find a way that's really original and fresh and interesting.

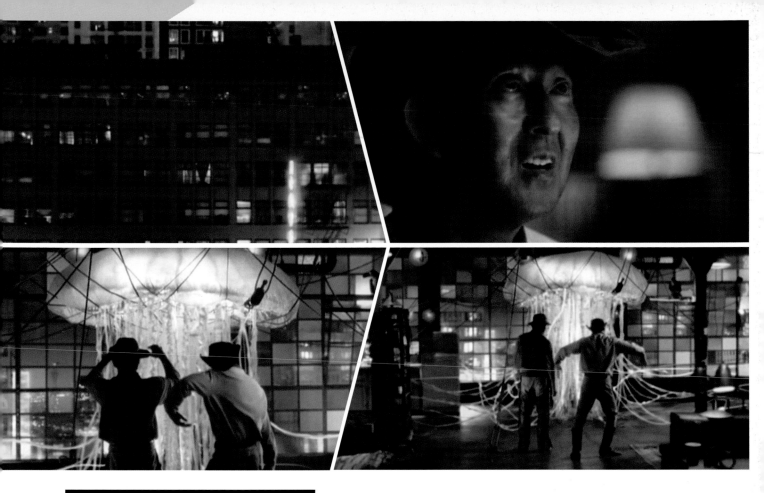

Technical Considerations

I love doing a load of different things with the lights and the camera, but I've become much less interested in technically driven jobs. I find I'm more interested in sort of soulful photographic work, the sort of work that involves people and performance and actors and so on. Sometimes it is fun to do a very technical job, and again I was very lucky when I was starting off, because most of the technical jobs were done in camera, and that was just fantastic. As an operator, I was working with some of the greats in the British commercials industry, people like Roger Woodburn. These were guys with amazingly inventive minds, who'd create magic in a studio in the back of a production company. You'd do everything in camera—very simple mattes or plates or stuff like that. That was really fun because it allowed the people making the film, the people shooting, to be involved at every level. The inevitable way that the complex jobs are done now is with a huge amount of post-production work, and again, the opportunity for happy accidents is much less. I've found the jobs that are done more in camera, and the challenges that come from that, are the more fun and exciting, because the results often have a special quality to them that you don't get when you can just digitally change stuff—that cold, slightly sterile thing that can often come from heavily post-produced work doesn't really interest me that much. Also it's just not that interesting from a production point of view for people like me now, because you end up shooting a lot of stuff on green [screen] and a lot of the creative work is actually done afterwards.

OPPOSITE & ABOVE: Three "Jellyfish" (WCRS/MJZ, d. Fredrik Bond, DoP. Ben Seresin).

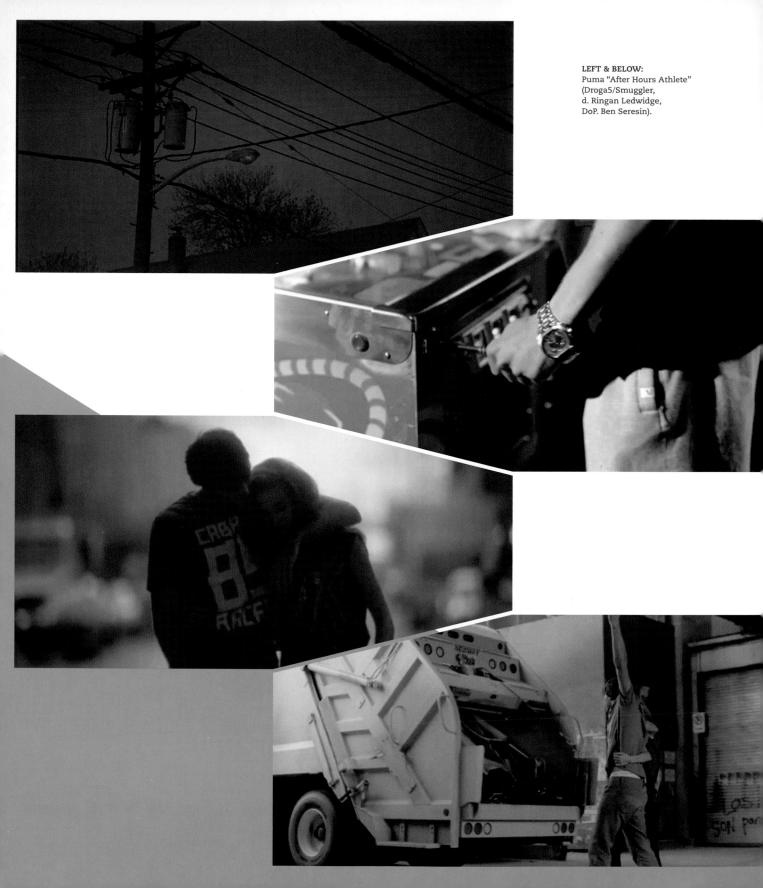

LEFT & BELOW:
Puma "After Hours Athlete"
(Droga5/Smuggler,
d. Ringan Ledwidge,
DoP. Ben Seresin).

Technical Challenges

I did one particularly challenging job for a jeans company, although I don't think it ever actually got aired—it was a little risqué. It was basically talking bottoms: it was really creatively brilliant, but I think it might have gone a bit too far . . . Basically the premise was four talking bottoms who go on a road trip and spend the whole trip complaining about trying to find the perfect, comfortable pair of jeans. There were various scenes with the bottoms in a night club having a drink, then back in the car, or wandering around the desert, and discussing the various aspects of finding a good pair of jeans to live in. It was absurd.

Technically, it was actually really challenging, because we weren't going to rely on visual effects. And the idea was to light the bottoms as though they resembled faces, and to do it in a very naturalistic style. The bottoms had to have contours that were recognizable, and expressions that resembled facial features. It was really challenging, because if you lit them in a normal way they just look like bottoms. So we had to come up with a technique of lighting where the dimples in them would somehow seem like eyes, and somehow show expressiveness. The kids [in their twenties] who were doing it were absolutely fantastic—they'd actually been cast on the basis of being able to make their bottoms have expressions.

We had a station wagon with the roof cut off, and the actors would be kneeling on the seats so their bottoms would be about at face level, and so you've got these asses hanging out of the window. Obviously there was also a decency aspect to this thing, which we had to deal with as well. Every set-up was incredibly complicated because aside from the lighting, you've got the framing—the bottoms are obviously like the heads, but there's a whole body above that you have to technically hide or frame out. I think one or two shots

we painted them out in post, like in a wide shot of the car going by. But other than that there were no visual effects. For something so incredibly simple it was incredibly challenging, but in a good way—one of the most technically difficult jobs I'd done, and driven by the fact that we didn't want to do any cheesy or corny effects on them—we just wanted them to be authentic.

Digital Photography

I shot my first digital movie about a year ago, and I have two distinct feelings, dealing with separate aspects of digital photography. Creatively, as far as my work goes, I've found a system and a camera that I think is fantastic; it allows me to work quickly in a totally new way because I'm able to see the result on a screen immediately. It's the [Arri] Alexa that everyone uses now—really an incredible camera. I think Arri have just done an amazing job, and it's become the industry standard almost immediately; as far as I'm concerned, having tested and shot with most of the other cameras, nothing comes remotely close to it.

The thing about digital is that if you come from a point where the best work results from an evolved aesthetic sense and visual style, you can apply that to any format you use, and the answer is to be able to realize that style and look and way of working in the most direct way, or the least watered down way. The process of shooting on film I love, because it has the discipline and the structure of a system that really recognizes the importance of an auteurship in the process of filmmaking, i.e. the director's really in charge of the overall vision and creative direction of the job, whatever it is. I love that, and I love the quality and the texture and the analog feel of film. It's still a very, very special format and medium to use.

Given that film is the benchmark, having worked with the Alexa, I was actually blown away by how well it replicates film. The thing I don't like about the digital process is that it can encourage the committee approach to filmmaking—that's been a real challenge to everyone from the director down. The system opens up the possibility of a lot of voices and a lot of opinions, because you're effectively looking [on set, via video tap] at something that's much nearer the final result; there's the opportunity for a lot of opinions to be aired, and that's not always a great thing. It can be, if that input is informed and disciplined; but on the other side of it, it can be a free-for-all, and that's where I think a lot of work has really suffered.

We're definitely moving into a digital world, and the system's being restructured. Directors for a long time have had to pitch their ideas and convince people that their vision is the best, and in the digital world it's now up to the cinematographers to do that. It's changed from when you could hide behind a technical level of expertise to now having to really explain your aesthetic sensibility, and talk people through the process much more, answer questions directly about the look, and really convince people that what you're doing is the best way. It's become a much more verbal job—there's a lot more explanation goes on, and the discussion aspect can get rather frustrating. For every person there's a different opinion, and unfortunately just the structure of the system these days means there's a lot of people around who seem to have nothing to do, so they feel obliged to give an opinion, and it's sometimes a little counterproductive.

I've found it very liberating in some ways, shooting on digital. I can shoot a lot quicker, and with support, I feel as though I can really experiment much more, because

BELOW: Barclay's "Strike Anywhere" (Venables Bell & Partners/ MJZ, d. Fredrik Bond, DoP. Ben Seresin).

I can very quickly look at the results and say, no that doesn't work, or try this, try that, that's fantastic. But it still depends on a strong aesthetic sense: for me, I want to see the image on the screen as close as it will be to the final transmission or broadcast or projection or whatever it is, so I can tell right away if it works or not.

The character of commercials has evolved, but not necessarily as a result of the digital developments. I've not been as immersed in them in the last couple of years as a lot of other guys have been, but what's interesting to me, and I question a lot, is that agencies or clients will mandate that film is shot digitally, and it won't necessarily be because of budget. I've never really been able to get a clear idea of why that is, and I think the fact is that there's a lot of misinformation about digital shooting. There are a lot of opinions, and there's a lot of talk, and there's a lot of bull, basically, particularly when it comes to the post process of digital shooting; sometimes people who have an interest in complicating the post process take advantage of that. One problem is that there's no standardized post path now, which is incredibly frustrating, whereas there was a much more linear process to post on film. The huge number of possibilities available, and overly complex nature of post now hasn't really helped anyone, and the results haven't been much better for that. There is some amazing artistry in heavily post-produced work, but that's only a handful of people, with an amazingly strong aesthetic sense, and they'd be able to apply that whether they were shooting digitally, doing heavily post-produced stuff, or shooting on a Super 8 camera. It's all about the talent and the visual sense.

Chapter 4
Post-Production

Although the process of creating a commercial allows for little radical change after the decisions of preproduction, the whole process from start to finish is characterized by a constant eye to how the commercial can be improved. Editing and other post procedures are no different in this respect.

foreground la elements

green scr-

BELOW: VFX elements for Guinness "noitulovE" (Abbot Mead Vickers BBDO/ Kleinman Productions, d. Daniel Kleinman, VFX by Framestore).

Editing

The involvement of the director and the production company varies at this stage. In America, it is fairly standard that the shooting and editing are handled by different entities. The production company is usually only responsible up until the day after the shoot, when they then hand over all the footage, and the agency gives it to an editorial company, who will spend two or three weeks editing it. In the UK and most other places, the director will more often see the job through editing and final picture and final sound. The dichotomy rests on a theoretical concept of who has the creative vision: for some people and cultures it is the director; for others, in the context of commercials, and particularly in the U.S., it is the ad agency.

Digital Effects and Animation

Likewise, the post-production visual effects company will tend to work more closely with the agency than with the production company. It is not always the case, and some production companies will have a skeleton post crew, hiring in specialists for specific jobs. The area of visual effects is so broad, and encompasses so many disciplines and skills, however, that it is rarely practical for the production company to handle this aspect in-house.

Occasionally a visual effects company will be brought in for a last-minute fix, but most usually the agency will involve them before shooting begins, simply to anticipate any issues, problems and impossibilities, and to allow the effects team to gather the necessary data on set to perform the post-production duties. Although there is little scope for change at this stage, there is still plenty of scope for tweaking, and as with every other stage of the process of making a commercial, refinement is the utmost priority: to create the best advertisement possible.

Various edits are likely to be made, usually starting with the editor's own cut, which may be transformed into a director's cut, a copywriter/art director's cut, or a creative's cut. Frequently there will be two or three different cuts of the same spot. Ego is sometimes involved, but more usually the prime concern of all involved is to make the best commercial possible—to sell the product in the most effective way, and thus to satisfy the client's original brief as fully as possible.

Dan Seddon: Visual Effects and CGI Supervisor

Dan Seddon is a Visual Effects and CGI supervisor with Method in Los Angeles and New York. He and his team have won several Visual Effects Society awards, for work including commercials for Guinness ("noitulove"), Halo 3, and Smirnoff ("Sea").

A Wealth of Possibilities

My title tends to vary from project to project: sometimes I'm visual effects supervisor, sometimes I might be CG supervisor, which is more specific, and I am just about to move to New York where I'll be creative director, which is more general. Whatever the title, the process is always at heart technical, with a mix of the creative: it's typically about putting CG visual effects into things that have been shot.

Visual effects is a really broad area. Sometimes we've done stuff that's completely CG and it might be realistic looking, and the next thing might not be realistic at all, non-photo-real, a cartoon almost. We don't tend to do a lot of non-photo-real work because that often goes to very specific companies, but what we do encompasses a pretty wide range. For example, Framestore, where I worked in London, specialized really heavily in creature work, which is partly historical because they did the BBC series *Walking with Dinosaurs* (1999), and they became very well-known for that. But creatures have got to the point nowadays where many people can do them, so Framestore

ABOVE: Bracketed 180° fisheye photograph for light probe.

have been branching out, doing more work on movies, and they're a pretty big company, so they've gotten into doing more shots on bigger features.

That said, companies still do have specializations. Method, where I work now, has done a lot of hard surface work (like a car, or a building, or something non-organic), but then we've also done a lot of effects where you might do an explosion because the production company doesn't really want to blow someone up. So you'll generate an explosion and that's almost like a completely different skill to doing a car or a creature—the person who'll do

that work will be particularly good at simulating that sort of thing: real-world random movement. It's just like you would simulate something if you built an aircraft. In fact, you'd use the same software almost, and it creates this nebulous explosion, which you then have to render out. That's something we specialize in a little bit, along with the hard surface work. I'd love us to get into creature work also, because it's really fun, and we've done some of that and are all set up to do more. All areas of what we do have a certain difficulty level, but it gets easier to do certain things over time.

Preproduction

The process would normally be that somebody comes up with an idea for a script, and once they go through the script they realize that one thing or another thing can't be shot, whether that's because it's fantastical or it's just not physically possible, such as a stunt. So they'll come to us and they'll ask us for a bid depending on how much work is involved, and we'll give them some numbers that they'll say are too high, then we'll come up with a way of doing it. So part of our job is finding what is the easiest way of getting that shot done, either by helping them shoot it so we can do a minimum amount of work, or coming up with the most cost-efficient way for us to do it.

Here in Los Angeles we tend to deal more directly with the production companies, so they'll be asked to go and shoot a commercial and they'll say, we need this effects work or this post work. Obviously most commercials have post work done on them, even if it's only color work or some idents, or very simple stuff. And they'll usually approach a visual effects company like us and get us to do the work. Now in New York the relationship tends to be more directly with the agency, simply because there are so many agencies there. It's a different world in many ways. The relationships can vary quite a bit, but the agency may well get the effects company in at the beginning of the process. Even in L.A., the agency should always involve the effects team before they shoot, and that does tend to happen to various degrees. Usually someone from the team will go to the shoot, and there'll be certain technical parts of the process that we'll always do if there's a major CG component in the shot.

Very rarely will you get something that they just dump on you and say, hey will you fix this; but you will sometimes get involved at different points.

Most of the work we do, obviously, is in the post-production, but after the initial preproduction consultation there's usually the previs [previsualization], which is where we'll use all the same tools to come up with a very lo-fi animation of what the commercial is. It'll have all the edit points already, and the director can kind of direct it and come up with what he wants to shoot before actually doing it. That's often done even on fully live-action commercials: a moving storyboard, essentially, that may help you visualize a shot that might be difficult to do even with live action. Before you're spending all the money on the crew, which is gigantic even on the smallest commercials, at least you've got a vague idea of what you're doing before you start. And on full CG commercials it's indispensable.

Every time you work on something that's been shot live-action, you have to recreate the camera move for that shot. It's frustrating because you'd think that by now someone would have developed a camera that could record its own movement, but the thing with visual effects is that no one ever thinks about us, and we just have to fix things for everyone else. So there's software that'll work out a camera move by tracking points in the frame from one frame to the next, and triangulate what that move is. Now for that you need to know what the lens is, and what the lens distortion is on that particular lens, so this is the sort of information that would be incredibly useful to compile—if everyone saved that information and shared that, then everybody would benefit, because then you'd just have to input a lens code.

LEFT: VFX elements for Guinness "noitulovE" (Abbot Mead Vickers BBDO/ Kleinman Productions, d. Daniel Kleinman, VFX by Framestore).

cg elements

cg elements

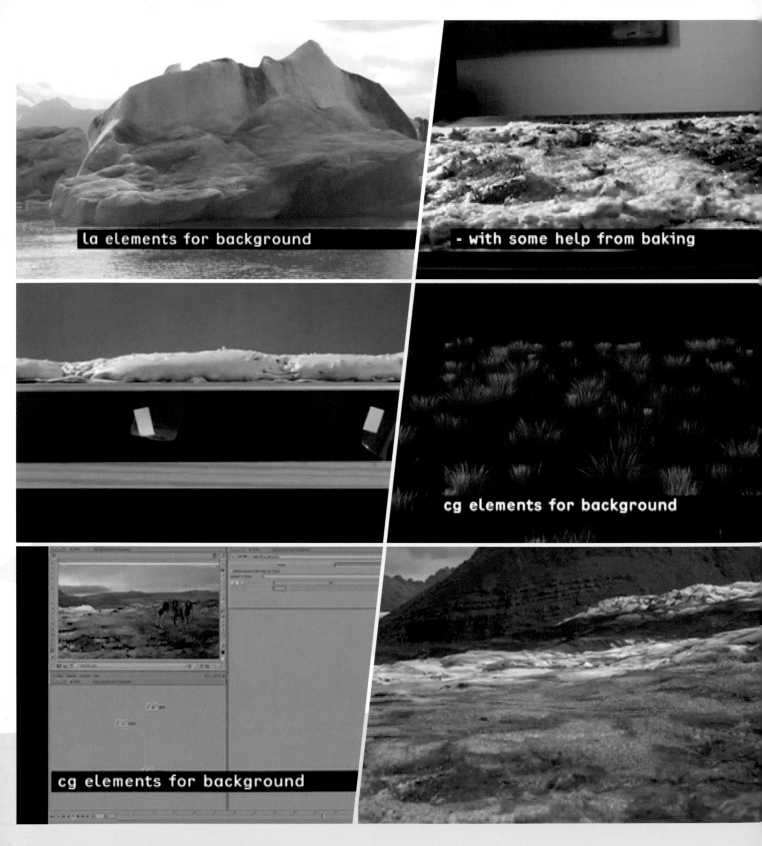

la elements for background

- with some help from baking

cg elements for background

cg elements for background

On Set

The technical things we do on set are normally taking a lot of measurements, and we take a lot of photographic evidence of everything we need to integrate with or recreate. We also need a lot of lighting reference, and there are several ways you can do that: the traditional way is that you take a fifty percent Gray Ball and you put that in front of the film camera, and obviously you know what color that Gray Ball's supposed to be, so it's an easy reference that gives you an idea of where the light's coming in from. Then you also do a Chroma Ball, so you see where the sun is. It's easy to recreate those inside the computer, and then you basically just match the look and theoretically the light's in the right place and you'll get lighting that's the same.

The other thing that's important now is you take what's known as an HDR, which is a high dynamic range image, and you create that in two parts. First of all you shoot with lots of brackets, like auto-bracketing in regular photography. It doesn't simply work out the best exposure for the main part of the image, however, which is what you can do if you use normal bracketing; its usefulness to us is that it captures information about the intensity of the light in different parts of the image, so that we can recreate the intensity itself, and then adjust the exposure.

Then what we'll do is a fisheye, or a spherical image that captures basically the whole environment, and that's taken with two or more fisheye lenses that can do 180 degrees, and it's basically like a light probe, because it gives the full lighting for a plate in an HDR format. Normally we have to somehow convince the director and the crew that it's important for us to capture these images between shots. They're getting better at it now, getting used to people like us on set, and they give us a bit of time. But going back certainly ten years ago, it was always hard to get the time to capture this information.

Effects and Post-Production

The schedules are really tight. That's a big thing about this industry: it's a relatively technical job, what we do, and you frequently get asked to do things that you don't know how you're going to do before you start. It could just as easily happen on an advertisement, but, for example, on a feature, we were recently asked to do an effect where one character is having his powers extracted from him in the form of lava, which would then traverse this massive underground chamber and start to reinvigorate the petrified body of his father, a gigantic lava monster. There's no pre-existing software that creates lava that comes out of a person's body, so you have to make it up, and you're almost getting into the territory of actually writing software, which is kind of tricky stuff. It's not uncommon to get things that complex on a commercial.

Straightforward animation, where it's really about the artistry of it, and understanding the nuances of movement, and coming up with some nice ideas, people get faster at it as they do it, and it's an art that's repeatable. But effects work is really at the other end of the spectrum. You're usually being asked to do something you haven't done before and you just have to get faster at problem-solving and figuring out how to do it.

Effects work like that is generally the hardest, taking something entirely fabricated and making it look real, and doing it on a short enough schedule. Even just lighting and rendering things is in itself a very hard thing to do, to make something look convincing. The human eye is very good at saying, that doesn't look right, even without immediately being able to say why. The technology's getting better all the

OPPOSITE: VFX elements for Guinness "noitulovE" (Abbot Mead Vickers BBDO/ Kleinman Productions, d. Daniel Kleinman, VFX by Framestore).

time, and the techniques for rendering, which is where you basically use virtual lights to illuminate and color the objects; the technology of doing that is getting better, and it's getting closer to reality. Nonetheless, things like textural detail and especially when you get into areas like creature work, which is down to the subtlest of textures and movement, you get in a situation where in order to make it look better, the processing on the computer takes longer because you're doing more computations. Just to create a single frame you can be waiting anywhere from ten minutes to two hours, and then you want to be doing iterations on that to make it look better. So you get into this horrible situation where everything is just going too slowly. That can be just as hard as a really difficult technical problem, like simulating an explosion, or simulating lava, or some other effect; making things look real, and making things that haven't been done before, and making things that haven't been done before look real—that where it's at in terms of difficulty. Also the reduction of schedules, because you might have done something that's really good and real-looking on the last project, but you can be sure they'll want you to do it in even less time on the next one.

For a commercial the average schedule is four to eight weeks. You'll get longer ones, and I've done commercials that have taken five months before, although I haven't seen schedules like that in a while. Usually that's because you need to do development work, or work out how to do the effects; or if it's creature work you'll be modeling and texturing and doing animation tests on that creature, or if it's got fur on, just grooming him and trying to make him look real. Then you'll execute the shots, and you might have thirty shots, each with different lighting conditions that you have to make look real, and each shot might take four or five days to light and render. Then if you've got

thirty shots you might have five people and they might all be doing different tasks, and it soon adds up. You have to bear in mind that because computers do things for you, people imagine it's all quick and easy, but it's not like that. It simply provides a different environment to that of the traditional modeler or animator. It doesn't take away that process: the process that we do on the computer is very similar. It's just that we can undo. And we've got to wait. Computers are slow, they're slow at working out reality. You don't have to do anything to make light bounce around a real, physical object, but to make that light and that object look realistic on the computer will take quite a long time. You have twenty-four of those images every second, and so many seconds in a commercial, and it takes time.

One of the things that's almost routine is removing bits of rig and so forth from shots. Also fairly routine is cosmetic work on faces. I don't do a lot of that because I do 3D, so it's the creation of things that are not actually in the shot; but the 2D side, a lot of that work is about cleaning up the plate which might just mean beautifying it somewhat, which would include the actor obviously, so they'll be painting out blemishes.

Every single project is different. There are some companies that specialize, and that makes things easier, but usually from one project to the next it's a whole new thing. So of course, wherever possible it's really good to reuse the sort of work that you've done before: if you've done some work with a creature in it and he's got fur, if you've got a really good technique for doing fur, you reuse it. It probably took a lot of time to develop it. Or if you've got an explosion already, you use that. It's really good to reuse stuff as much as possible, but at the same time it'll only have a certain shelf-life, because the technique you used two years ago has probably been superseded by something newer and better by now.

ABOVE: VFX elements for Guinness "noitulovE" (Abbot Mead Vickers BBDO/ Kleinman Productions, d. Daniel Kleinman, VFX by Framestore).

Some companies will handle the whole video post-production end: Method has a sister company called Company Three who does grading and color, and they'll usually do all of that work on our commercials and vice versa, and we use that relationship. But it doesn't have to be like that: sometimes the client might want to do some part of the process somewhere else. Obviously it makes sense for one place to do it all—one of the things about the CG part of the process is that it's relatively technical and if you want something to look real, the lights to replicate what happens in the real world, then one of the things you don't really want to do is some crazy grade on it, something that couldn't really exist in the real world, then try and light something to synch with that plate. There should really be no grading on the footage we work on: the grade should be applied to the full, finished work. That's the best way of doing it, but sometimes it's not very well organized. You'll end up with plates where the grade's already partially done, and it makes it a lot more difficult for the CG. Having a good process along those lines is much easier if everything is done at the same company and everything works together at the same time. The more things that can be contained within one place the better, really.

Hurdles

In terms of the production process, lack of decisiveness and anticipation are definitely the most problematic: laying out numbers based on generalizations, and then suddenly finding out that one shot, although it might look fairly straightforward, you suddenly realize it's fifteen seconds long, and it's as much work as all the other shots put together. It's just about keeping ahead of how much work is involved in each shot, and things like how close do you get to the CG asset, as they often get called. If it's a

ABOVE & OPPOSITE:
VFX elements for
Guinness "noitulovE"
(Abbot Mead Vickers BBDO/
Kleinman Productions,
d. Daniel Kleinman,
VFX by Framestore).

creature for example, you don't want to get too close to it.

Another thing is that, of course, there's always a drive to do better work. The temptation there can be to feature your work as much as possible, but at the same time you have to be realistic and not embark on something that can't really be done in the amount of time. That's what it boils down to: not getting too close; if it's a lengthy shot, realizing that it's a lot more work than a shorter shot; and making sure that the decisions are there. Ideally everything should be storyboarded—it isn't always—and then making sure all the legwork's done upfront, like the animatic work, making sure you have the crew, making sure you have the people, making sure you have the time.

The process is further complicated by the sheer number of people in the decision-making chain. In the U.S. it's even more so, but the UK is a lot flatter in terms of hierarchy, even just within the team.

I wouldn't expect to supervise people on my team all that heavily, and they wouldn't sit there waiting for me to tell them what to do, but it tends to be more hierarchical here in the States. It wasn't until I came here that I understood the concept of what they call an off-the-box supervisor, which refers to somebody who doesn't actually sit down and do any creative work, but goes around saying, hey do this, do that. So you might find on a project that the first thing you've got to do is to make this supervisor happy, then the production company, then the agency, and finally the original client, any one of whom might turn around and say, oh, I don't like that. There are a lot of changes that are just down to one person's idea of how it should be, and that's routine. Ultimately, there's always somebody who wins. Very frequently there'll be a situation where we'll do a director's version, because the director will like their ideas better, and almost always it's different from what the agency wants.

The Road to Visual Effects

I studied Engineering at Manchester University and that introduced me to CAD [Computer Aided Design], which really caught my interest. I had done Art in high school, and then went off in a more technical direction, but when I was studying engineering I was drawn to the CAD side of it, and more particularly to how the CAD software would let you literally finish final images and do a little render of what you're trying to make; I found that more interesting than the usual options available with an engineering degree, and I ended up doing a Masters in Computer Graphics—that was how I got into the field of visual effects. The first company I worked for was the BBC, when I first graduated, on a documentary series called *The Human Body*, which won us a BAFTA Award, and I went from there and started working on commercials.

Nowadays it's usual for people to come into the field with a specialized degree, but when I got into the industry fifteen years ago there weren't courses that were specific to doing visual effects. There were courses like the one I did, which was a masters degree, and which have more of a slant towards the actual technical side like computer graphics in its whole sense. Now you'll get courses that teach you animation and all aspects of post-production. My generation would certainly have come either directly from an art course, probably directly from engineering, or maybe from a computer graphics course. But the younger generations are studying specific aspects and are ready to work straight out of college.

Here in Los Angeles, we get a lot of people from Savannah College of Art, and in San Francisco there's the school of Animation & Visual Effects. In Europe, Bournemouth is actually very big in the UK, and then there's Gobelins in France. The visual effects work that comes out of

France is amazing—they're really good at combining the artistic and the technical, and the reels that come out of those students are terrifyingly good. They're already good to go and they've only been doing it for a couple of years. There's also Supinfocom in France, and then Germany has the Film Academy, which is also very, very good. I would say that those are the top schools—France and Germany—even though strangely there's not much of an industry in those countries. It's generally London and L.A.

My company, Method, has maybe two hundred people in L.A., probably around fifty in New York, and perhaps 150 in Vancouver. Less than a thousand total, but as a company that does commercials, that's still pretty big. If you look at a company like The Mill, who are huge in New York, they might have 150 people doing only commercials; but then a place like Framestore are probably about fifty

in London, thirty in New York. The commercials companies don't tend to be enormous, since the scale of the work is that much smaller, as opposed to say a film company like Sony up the road in Culver City, they'll have hundreds of people, sometimes thousands, all working on one thing, because they'll routinely be doing five hundred shots—in fact, it's probably more like one or two thousand shots these days.

There are only a few companies who do both films and commercials. Method is one. Framestore do both, Digital Domain (also in L.A.) do both, as do Weta, based in New Zealand. We just did a feature, *Wrath of the Titans*, and that was our biggest project. When that was running it occupied a good sixty percent of the company for nine months. There's a smaller feature going on at the moment, but now we're doing more commercials, and I would say for most of the last three years when I've been there

BELOW: VFX elements for Guinness "noitulovE" (Abbot Mead Vickers BBDO/Kleinman Productions, d. Daniel Kleinman, VFX by Framestore)

it's been mostly commercials. But every now and again a feature will come in, and they usually occupy quite a large proportion of the company, so maybe it balances out, maybe time and manpower-wise about fifty-fifty. Although the schedules on movies can seem a little less pressured than on commercials, it can be brutal on a movie because it takes so long; you might have somebody working on a particularly difficult shot for six months, which is not unheard of, and one of the difficulties might be that it turns out that conceptually it doesn't really work, and then at some point the director might realize that and cut it, and that's not all that uncommon.

The Industry

Everybody pops up on the horizon now and again with a good piece of work. The Mill (New York) does a lot of commercial work. Framestore does good work. Method does very good work, of course—we're very well regarded. It all goes from project to project: on one project someone will do something that's stunning and everyone will try and replicate that. Whereas with film it's been more clear cut, where ILM (Industrial Light & Magic) and Weta have tended to be the leaders, largely because of the size of the projects and budgets that they get.

There's definitely a sense of trying to outdo one another. Even on an individual level, if you see some cool work, and you do work that's similar to it, then you're going to want to outdo them, do something that looks better. There's a lot of that. But in fact there's also a certain amount of sharing of technique and knowledge

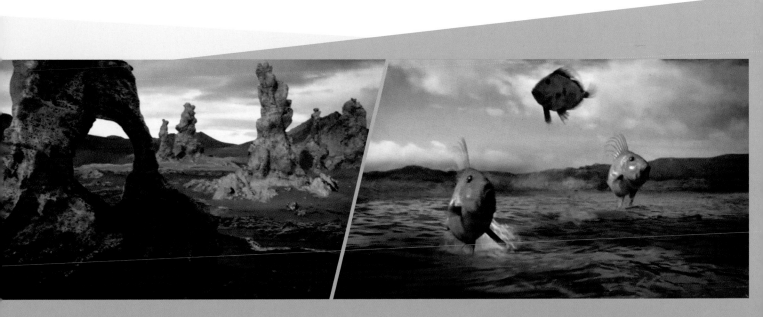

between companies: there's a conference that takes place each summer called SIGGRAPH [Special Interest Group on Graphics and Interactive Techniques], which is an international conference that started off in the Seventies and was all about the purely technical techniques of rendering and doing things inside a computer. Now it's grown into a larger conference for anyone in the industry. There'll be talks on how we did these shots, how we achieved that. It's not really necessarily in the company's favor to share that information, but it is really in the artists' favor to say, look what I did, isn't it cool. People are generally quite keen on letting other people know what they did. And also there is a bit of kudos for the company to say, look we can do this clever stuff that looks really cool, look at us.

SIGGRAPH is the main one of these conferences, and takes place in North America; there's also one in Germany, FMX, which is more of a European one, and there's also SIGGRAPH Asia and a few other smaller things, but there's not that many because people in our industry tend to be pretty busy, and don't tend to have time for a lot of conferences. As far as awards go, the VES [Visual Effects Society] are the most prestigious for our industry, for which the ceremony is every January, and there are awards in all categories, so there's movies and commercials, right through to the ride films that you get at fairs and theme parks, and all kinds of stuff. The most recent award we received was for [the game] *Halo Reach*. It's almost two years since we started it now, and then we got an award for it last January. Prior to that, actually in the same award category, we did a few commercials for Danny Kleinman who's one of the most respected commercial directors in the world. One of those was the Guinness "noitulovE" commercial, which is evolution backwards, and it's where everything goes sort of back in time. We played it forwards just for fun

and it actually it works, going forwards, funnily enough. And then there was another one called Smirnoff "Sea," which is kind of crazy, with things being thrown out of the sea because it's the water purifying itself; and then a couple of other awards for creature work. I'm also really pleased with a lot of the creature work that I did at the end of my time at Framestore, because I helped develop the process for doing that, like the CG stork we did for Monster.com, which ended up looking really nice. So we've received a few decent industry awards, and then a few others, but it's the industry awards that you care about, because that's people who do the same thing as you do.

BELOW & RIGHT:
VFX elements for Smirnoff "Sea" (Abbot Mead Vickers BBDO/Kleinman Productions, d. Daniel Kleinman, VFX by Framestore).

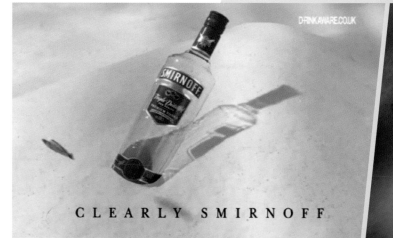

CLEARLY SMIRNOFF

DRINKAWARE.CO.UK

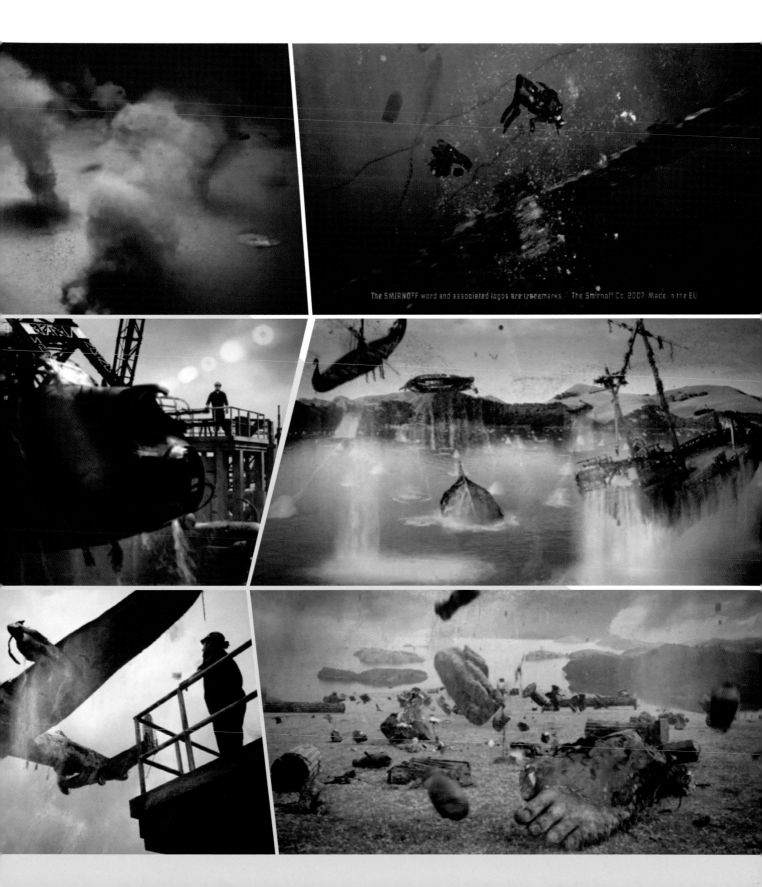

Steve Gandolfi: Editor

Founder and owner of Cut+Run, Steve Gandolfi was the preeminent editor of the British commercials industry until his move to America. Worldwide domination is now underway. He was voted Britain's Best Editor an unprecedented eight times and is the only editor to be named part of Campaign's A List for six years running. He has won several Cannes Lions, for commercials such as Smirnoff "Sea" and Monster "Stork," and has received multiple recognition from all other major award-giving bodies in the industry, on both the creative and the business sides.

BELOW: Starbucks "Snowflake" (BBDO Chicago/ Epoch Films/Rattling Stick, d. Daniel Kleinman, ed. Steve Gandolfi).

Beginnings

I wanted to work on TV. I was getting my hair cut one day when I was about nine years old by this lady who did make-up and hair on sets, and I said to her, that's what I want to do, I want to make films and adverts and all that. She said I had to start off being a runner, and she took me along to a film set. It was really weird, and I don't know completely what happened, but it was a pop video, and the pop star asked me to get him a hamburger and fries from somewhere, some different shop. I got invited back, and I used to help out and do stuff. That's where I got my first taste.

I applied for a job with the BBC when I was fourteen and a half years old and they turned me down. I've still got the letter now. I went on many years later to cut BBC Christmas Day Specials and things like that. But I worked in a sound studio when I was very young—I started before I should have started really—and that's where I met Ian Weil. We got the most amazing directors and producers through the door, and for us they all turned into superstars. We worked with all these amazing people.

I remember standing behind Paul Weiland—he's one of Britain's biggest commercial directors—I was standing behind him watching him edit "Water in Majorca" and this woman says, "The water in Majorca don't taste like what it oughta." He was deliberating about certain shots, and I remember thinking, Paul, this is just so funny and great, what are you talking about? From an early age I was blessed to be around these people who are always pushing themselves to get it better. It's like the best directors today: every job, all of them are always pushing themselves to get it better. It taught me from a very early age, and I love it. It's given me an amazing career.

I cut on Avid, but I've cut on everything. I cut on film for fifteen years. We did U-matic, which is three-quarter-inch videotape, Final Cut, and so on. I've cut music videos, television, commercials, long-form things, but I mainly do music videos and TV commercials. I don't know why. I enjoy their particular challenges, and I've seen a lot of pain doing films. But that's for now—you never what the future holds.

Editors are quite odd people. We spend a lot of time in dark rooms. Except me—Daniel Kleinman was one of the first to incorporate editing on set: location editing, twenty-odd years ago. The transport of equipment was very costly and unheard of at the time, but he wanted to cut it on set, and see what he was doing and all that. So we used to spend between six and nine months on the road, which was not healthy for the personal life. But it's common now: some editors love it, some editors don't. I believe it can help the process.

On Set

One useful aspect is that you can edit what you've shot the day you're shooting—we've got a tap from the camera and a lot of directors without asking us will always give you the nod, to see if everything is okay. When I'm on a set I stand behind the director and I listen to exactly what's going on, and that's where I start. From there I always cut what I feel as well. You're the editor: you're employed to edit the best film possible. I think some editors don't want to go on set, because they don't want to be influenced by what they hear or by what's happening on set. But I still go away and do what I think's best; even though I've heard they want that shot for there—I'll show them that, but I might also have the chance to show them something different. If I can add even one thing to the edit they use, then I've done my job.

Editing on set is a bit of misnomer; we're actually often not on the set at all. I've edited on golf carts, in backrooms,

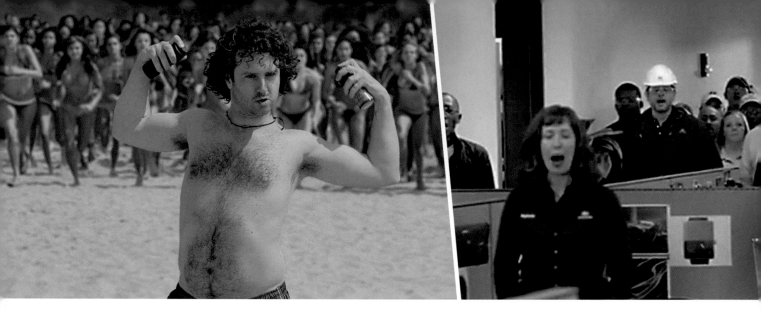

hotels, in the bathroom (yes, on toilets!), and next to waterfalls. It makes no difference to me where I edit. Wherever you edit it's just joining up. So working on set or in an office, I don't really mind. There's no difference, but some directors use the on-set editing properly, and it really does help.

The Editing Room

We call it the altar, the editing room, because you can see producers and directors on their knees thinking, oh hell why did I shoot that like that? Praying, almost. It's the first place you actually realize if it's amazing or if it doesn't work. Do people really know when they're on set if what they're shooting is as fantastic as what they think, until they've seen it joined up? When you join it up—even if it's one shot—it's the first time you actually see if the thing is any good or not. People have their bit of paper and they say, I'm going to do this big sweeping shot and I'm going to do this and that, but you get in the edit and you look at it and say, hmmm, naah . . . or something worse.

The other week I was on set with this creative director from an agency and he was forever moaning about stuff. The crew kept saying, why's he carrying on about

this, that, and the other? But he was just putting his point across, and when it got to the edit suite you could see he knew what he was talking about. There were some problems. At one point we had to lose a shot, and then you remember there's that shot he suggested we can use instead. A lot of directors are like that too—they work out all the problems. It's like editing a jigsaw while creating all the pieces.

The editing room's pretty mad. As an editor, you've got to get the idea across, the story, or you can create something completely different. But you'll also always come across problems, like continuity problems, light problems, etc. There was a reality show that once wanted to put cameras in the editing room, and we really wanted to do it but if you ever did, it'd be one season and then you'd be unemployed for the rest of your life. You see and hear everything there.

We had this one kid who talked his way into the job saying he wanted to become Britain's best actor, and I thought it was so cheeky I hired him. He just stood behind us, watching us edit, and learned from the directors, the top directors in the world; he listened to them and watched them watch their dailies, moaning about actors. He left after about four years, and

a couple of years later he got voted Britain's best Shakespearean actor, and now he's done a bunch of Hollywood A-Class movies, because he just stood in the editing room and learned at the altar.

More Than One Way to Cut a Spot

In America, the agency's a lot, lot more involved in the editing than in the UK or Europe. Each creative could possibly do their own edit. You have a copywriter/art director, creative directors—there could be two other edits floating around, other than the director's edit. They want to try everything. They're on set and they see things, and they say that doesn't work, that does work. As an editor it's quite a pickle, who and what to listen to. Editors should pay attention to all of that. And then we just join up what we feel is the best.

I think the agencies still trust the director, but over here in America the director is not always as involved in the edit. Sometimes, the agency is in straight after the shoot. This can happen even to the big kahunas. There are very few jobs over here where the director will sit in the room for more than a few days. As an editor you have to be very, very diplomatic and make sure that everyone's kept happy. The director comes in and does his edit and two weeks later he'll see their edit and he'll say to you, what the hell is that all about? You always bear in mind what the director wants, but it's also the creatives' idea, and it's their client who has to be kept happy. You try to satisfy everybody, but it's slightly hard to satisfy everybody in life.

It's the creatives' job, with the producers, to make sure that what they presented to the client, what they signed off on, is what the client's going see. But when you're shooting stuff they come up with other ideas and want to try other versions. Some directors shoot them, some directors won't. It's part of the process now; even in England it's become more and more that the agency want to try their version, even when the director's done something great but they want to try their own one. You sit there and take it all in and you figure out what's what and how to make everyone happy while coming to the best end result. As an editor you have to embrace it, and you have to do everything, to be perfectly honest. You try everything and then stand by what's best.

To Cut or Not to Cut

I've done something like four or five of the top ten funniest ads ever made. A few of them were all just one shot, like John West Salmon—they had no edits. With John West, we tried putting in all these edits, and then we said, no, this is crap. It was better as one shot. I was in Canada and I heard these kids saying, have you seen this ad where there's this bear and the guy kung fu kicks the bear? And I knew it was going to be a smash. I'm sure they sold a lot of salmon.

It's completely different cutting a story ad, say two people talking, from cutting something like a car ad. With dialog you have to get across the emotion. With car ads you really have to absorb the feeling they're trying to achieve. And whether it's a Nissan or a Toyota or whatever, it's all about the angles. Editing these two types of ads is completely different. Some editors are good at one and some are good at the other, and some of us do both.

It's quite interesting: you can get pigeonholed as an editor to cut one or the other and it's horrible, because as an editor you should be able to cut anything. The main difference is between commercials and films (long format). When you cut from one to the other you just have to switch off. You mustn't cut a movie like a commercial. Some editors who go from commercials don't understand this. The difference is hard to define, but the timing and everything's different, the pacing is different, the amount of emotion you get in your edits is different. You just let it chill. Unless you're cutting like Tony Scott—all his films were quicker than TV commercials, but that's how he became really famous, because he's rock and roll. He pulled it off because he was brilliant at it.

I teach a lot of editing to young people, and I have this thing where I take a still picture of a woman, a black-and-white picture, and I tell them to edit it two different ways to show two different emotions, and I'll be back in half an hour. I go down to the pub and I come back, and they've cut the picture in half and they've blown it up and they've put effects on it and all that, and I think it's really cool; but I open my laptop and I play the exact same picture twice, once with happy music and once with sad music, and I say there you go, there's two completely different edits.

Anyone Can Edit

Everybody can edit—everybody can join up two pieces of film—but to do it well you've got to join it up in a certain way that just makes it look cool, makes it look right. Some people nowadays don't use good editors, and it really shows. There's a job out at the moment shot by a really big director, and the edit's just not very good. He used a friend of the producer to edit it. It's really sad because the spot could be quite good, but it's not, and it's down to the edit.

People don't understand the importance of editors, and it's very important in the film industry, but editors are rubbish without directors. We need directors. People like Daniel Kleinman, and Tom Kuntz as well, they put me to shame. I spend three days on my own trying stuff and they come in and say have you tried this, and I'm like, damn, I never thought of that.

A lot of editors think they're directors. A lot of Flame artists think they're editors. I'm not sure it's so. I've tried directing, and it's completely different from what I feel comfortable doing. You give me a load of dailies, and I'll join it up ten different ways and people will say, wow, that's good but it's not what we want, we want this that and the other. And so I'll take their ideas, and what I've done, and mold it all together, and we make it better.

OPPOSITE TOP & MIDDLE: Coca-Cola "Border" (Weiden + Kennedy/Furlined, d. Adam Hashemi, ed. Steve Gandolfi).

RIGHT: Heineken "Moustache"
(Weiden + Kennedy/Biscuit,
d. Noam Murro,
ed. Steve Gandolfi).

How to Do It

You look at the storyboard and you join it up. That's where it all starts. The role of the editor is to join it up like they want it, but once they start shooting and you have the rushes you might do something completely different. You've got to push the boat. You have to give them what they want, because otherwise you're going to get in trouble, but you must always say look at this, and show them something they hadn't thought of. One problem nowadays is that budgets and schedules are so crunched. But you can't let that compromise the work. There was a period in my career when I never read the script or looked at the storyboard, and I'd join it up to see what happened. Then I would read the script, and look at the storyboard, and do it again. There's a couple of directors who let me edit for a few days on my own then look at it and say, yes, or no that's a load of rubbish, and then we completely start again from scratch. When we have a director's cut they like, we sit side by side and we look at the different edits. Sometimes we stick with the director's version because its better, and sometimes we take bits and bobs and create a hybrid.

I look at the footage twice. Some people look at it more, some people look at it once. It's crazy. Some editors take all the dailies and join them all up; some editors—a really famous editor I know—doesn't look at the dailies at all, but just looks at the last take. He takes that, and after he's edited it he goes back and takes a look at the rest. There are all these different processes. None of them is right or wrong. It's just whatever you want to do to get the process done.

Working with Effects

Once the agency has an idea approved by the client, and they have a director and VFX house on board, they will often have a previs made before shooting begins. At this time they begin to work out what's possible given the creative, budget, and schedule. What should be done practically, what is done in post, what elements will need to be shot, what props/art production are required. In addition to the schedule leading up to the shoot there is the schedule for all of the VFX work—matte painting, tracking, compositing, lighting, etc. All of it must be done and this work takes weeks, sometimes months. The director works very closely with the special effects house and talks to the operator, or the flame artist, or the visual effects supervisor—collaboration is key. As an editor, you must know the number and length of the VFX shots before you go on the set; you look at the storyboard, you read the scripts, you read everything, so you know which shots have special effects in.

What we do is call up the special effects house and say, oh you know on that job, on shot three, what's going on there? And they say, he's going to put stars in, so you need to make sure that shot's one and a half seconds long. As an editor, you look at the shot and know that actually it might be one second, or it might be two or three. On a big job the director will always have a visual effects person on a set when they're shooting; it's a balancing act, and we're all on the tightrope working together. Because if anyone says "Yeah, that'll work," and they're wrong, it can cost them a car. On set you will hear, "Is that alright?" "Yeah,

it's fine." "Alright, let's move on!" You've got to make sure you're right, otherwise you can get really caught out. We work very closely with visual effects people because it really helps us. They give us stuff, we give them stuff, we overlay stuff into the edit, so when the director comes in, or the agency comes in to see stuff, it's all kind of semi-gelled together.

The Digital Age

Now the video camera's come and a lot of people don't know how to say "cut." We have a massive problem in overtime now, for assistants and second assistants, because of the amount of footage. We get masses and masses and masses of footage now on jobs. Whether it's right or wrong, I don't know.

Another change that I hadn't thought of: there was a big music video we did last year, with a huge director, and we ran it to the band who looked at it on their computers and said, that's great. Then they said, can we stop, and they got their mobiles out and looked at it on their Samsungs and their iPhones and said, yeah looks great but we can't use that wide shot because it's too small. So much now is looked at on these things it's really mad, because they're only three by two, or two by whatever. The director and I looked at each other and thought, oh hell, that's right. Technology has changed so much.

We also do a lot of longer stuff now too. Basically, for every single commercial or spot, they would like a version for the Internet. We just did a huge car commercial, and the ad was a sixty and a ninety [seconds], and we did a two-and-a-half-minute version as well. They do that a lot.

But editing hasn't really changed, I don't think. We still turn up and go on set, or we do it in our dark room, and we just sit at our altar and chop it together.

Brave New World

Before digital really took over, all the post was separate. There were offline shops: coloring, finishing—they were all separate. Now it's a bit more blended at times. Some editors color, some jobs finish straight out of Avid, some FX houses try to do the edit. I think, though, that everyone has their niche in life, and some people think they can do everybody else's job, but actually they can't. You spend a long time learning a skill. Editing's a trade.

In the old days it took you a long time to become an editor. You watched a top editor like Ian Weil, and they'd just mark it and they cut it. When I started editing you'd mark a frame with a chinagraph and you'd think, I've got to put an extra frame on because it doesn't edit, while picking up the clip from the bin. When it went through the moviola it used to click and everything, but now you can add a frame, take one away, you can practice, you can do anything—it's fantastic.

Youngsters now are impressive—they can edit on their computers and they can do all the effects, but the basic skill of editing is unchanged. A lot more people do it now because they can go down the road and buy a computer and do it themselves—it's so cheap. But if the editor's any good, they can make it into something else. Anyone can join up film, but can everyone edit? After about three or four years you know if you can edit, and if not you're on to something else.

ABOVE: Adidas "Impossible Field" (180 Amsterdam/ Kleinman Productions, d. Daniel Kleinman).

"Impossible Field" for Adidias was an amazing ad to edit. That was a director at his utmost supreme. Kleinman planned it to a tee; he and his producer knew exactly what they were doing. They went and shot the superstars, then they shot all the body doubles, then they went back and shot the superstars again, and we used to cut it every day. I cut it in the day with Kleinman when he was shooting it, and then at night he'd go to dinner and I used to sit there on my own and edit it, and then we'd sit in the morning with his producer Johnnie Frankel, and we'd just work out every angle. Same as on the Audi "Wakeboarder" advert he did, if

you look at how many different camera angles there are in that.

We edited it on set, but Kleinman uses editing on set for a different thing. He doesn't use it to see if it works. He knows it works. He uses editing to make it better. That's what you should do when you edit on set. He just picked up so many camera angles, like putting a camera on the guy's hands and stuff. The same with "Impossible Field." He'd worked out all the shots he wanted and he looks at the edit and he can see when he needs to make things better, or if he wants something from a different angle. The whole process was brilliant.

Chapter 5
New Horizons

Commercial advertising has always been in search of innovation, of new ways to capture attention and to attract an audience. Never before, however, has it found itself playing catch-up to quite such a degree with the proliferation of new technologies and advertising platforms. There are a multitude of new ways in which to transmit the advertising message, and these mushrooming conduits have also served to bring the corners of the Earth closer together. The same advertisement can be viewed simultaneously in Vladivostok and Timbuktu, in an increasing number of different ways.

LEFT: Nike "Write the Future" (Weiden+Kennedy/ Anonymous, Independent, d. Alejandro Gonzalez Inarritu).

Before consumers had so much power in their back pockets, or in the multitasking, multimedia box in their living rooms, the Internet was opening channels of communication, and prior even to that, global broadcasting of television and radio broadened the potential audience for advertisers. The result has always been an urge to make advertisements that can play to the widest possible audience. This is bolstered by the fact that the targeted territories can be expected to contribute financially to the campaign (and are most usually targeted for their potential to do so).

The danger of globalization, in advertising as in any sphere, is the risk of blandness, of trying to please all the people all the time, in hugely disparate markets. On a more practical level, these markets may also have their own version of the aerosol deodorant, for example, that is being marketed, which makes for a time-consuming complication on the production side: shots that feature the product must be repeated with every style of aerosol from the different markets, as well as multiple variations in text and speech, and it can become a very laborious process. Furthermore, the huge number of available outlets encourages clients, agencies, and production companies to stretch their budgets thin, to produce content for as many of these outlets as possible.

Which is not to say that this approach cannot succeed. Nike's World Cup tease, handled by Weiden+Kennedy in 2011, debuted in forty-one countries simultaneously with a parallel online campaign and experiential marketing pieces throughout all of the various cities. The result was a world phenomenon. It is considered the most expensive ad ever made, costing around thirty million dollars, and while neither Nike nor Weiden+Kennedy are likely to confirm the numbers, if asked they would doubtless say that it was worth every penny.

Although the traditional television advertisement retains its preeminence, its proportion among all filmed advertising has greatly decreased, as quicker and easier outlets have become available via the Internet, and budgets can be squeezed to as little as $20,000. What this means for the ad-makers is that while they can now reach a truly global audience, their voices are also competing with the new voices across the world, and even competing for the same jobs. Price pressure exerts its effect; the demand for content has soared and the lowest common denominator remains predominant. Traditional film-craft holds strong, however, and good advertisements cannot be made without it; but for the ad-makers who keep up with these ever-more efficient and powerful methods of production and distribution, they can be harnessed to remarkably successful ends in terms both of selling the product, and of creating new forms of commercial.

Life Beyond Television

The most successful television commercials will have an afterlife of online sharing, but without the television launching pad, it remains a struggle to distribute commercials successfully online, where over forty-eight hours of video are uploaded per minute. On the other hand, expanded distribution can be purchased by the advertiser through a pay-to-click model; social media, online video channels, and even spam help reach an audience whose target demographics are constantly being refined. Internet-only distribution has yet to produce any game-changing success stories, but the gap between the Internet and the traditional television-viewing experience is fast closing.

Online reviews and opinions demand more engagement with the consumer, but can also feed back more information to the marketers. The sense of personal engagement is most radically altered by the consumers' increased control of where, when, and how they engage with media. Kumar Doshi is Global Brand Strategist for the Branded Entertainment and Experiences Team at Microsoft Advertising. Their mission is to push boundaries on brands and people. Doshi explains that it's about "having meaningful conversations, essentially. Which might be a euphemism for advertising, but there evidently are new relationships that you can have. This is partly due to how people are spending their time differently. We were seeing it ten years ago, but it's far more the case today, that more and more time is going away from the television into other media. A few main things have happened to allow people more control. There's no scheduled viewing anymore. It's all on myTime. I can watch eight episodes of *Breaking Bad* and fast forward though all of the commercials if I want to. We have much more control over how we manage our content consumption.

"As a consultant for new media platform advertising, our team can be presented with a company's brand at almost any stage of its development. We love to be brought in early, and we can work at any level of the process: with the media agency, the creative agency, or directly with the client. Our approach is very simple: we start with people, and what they're doing, the people whom you're trying to target. Then we can ask what your brand is trying to communicate to these people, and what relationship you want to have with these people. Born out of that is the real experience, whether it's a video, or something much more experiential, or something much more passive. It will all depend on the first two ingredients, which are people and the brand. What we bring to it is an understanding of how to reach them in new platforms or media.

"There are other trends that have happened, but the main one is that the TV screen is no longer the single screen in the home. And on that premise we built a team that said, okay, if people are changing the way that they consume content, then the world of brands is going to change as well. That's not to say that TVs are dying or are dead. The terrific work that is being done on smart TVs is going to be the revitalization of television. But film- and video-based advertising, and the fifteen and thirty second spots, have totally changed, and there's no apparent stall to that change.

"Initially people freaked: the fifteen second spot's dead, the thirty second spot's dead; they saw the amount of people who were moving away to DVR, or TiVo. But advertisers have found new ways to supplement their perceived loss. In fact, the fifteen- and thirty-second commercials have not been lost as much or as fast as people initially predicted, because the general population is still watching television. But the smart advertisers are still looking around the corner and saying, okay, I know I need people on Facebook, I know I need to think about a social media strategy, I know I need to think about a

Twitter strategy, and they are somewhat wholeheartedly going after it. It started that an edict from a lot of the CMOs among the top fifty brands was simply to get a million likes on Facebook. Maybe they weren't thinking about what that meant, or what that brought to their brand, or whether it was even right for their brand, but they just felt they needed to be in there. Now they're thinking more about what that really means.

"The first question I ask in a meeting is, do you have an appetite for innovation? And if you don't, if you don't have the stomach for this, we can sell you something else. That's not a problem. They all think they do, so we go hand-in-hand down the aisle, and at the last minute some of them will say, wait a second, I'm not sure. Those are the interesting conversations.

"What's curious is that still many of the people who are making the decisions at advertising levels are not really well-informed about the new platforms that are constantly coming out. They're very reliant on a media agency or their partners, instead of going out and educating themselves. Obviously there are exceptions, more and more now, and expertise has developed such that we do see campaigns that are really targeted along and driven by these demographic lines. Facebook and Twitter and so forth are just distribution means: whatever you want to communicate you can tap into millions of people, and communicate the message you want to communicate, and obviously by now these are media that you just can't ignore."

It's hard to keep up. Self-education by marketers and agencies must be done on the job, or on their own time. Even if they can afford the time and money to do this, the pace of change is unremitting. But it's also hard for the consumer to keep up. The mass of Internet and wireless information available today at the touch of a button was not something the consumer had to consider until little more than fifteen years ago; now that we're aware of this information, we're all the more aware that we're missing out on something, somewhere, all of the time. The result is, most basically, a lessening of attention, which makes it imperative for advertisers to explore new methods of effectively conveying their message.

Doshi continues, "There's been a great deal of research done into what people are willing to watch, and at the core of that research there's nothing new: if it helps the person, and sells to them, then they are willing to watch it. The result is that the role of the advertiser, and of this technology in general, is really to map what it is that you want, and to serve that up at the right time. It's not yet been perfected, of course—everyone still sees a lot of stuff they're just not interested in—but as it become more refined, it will get more sophisticated and relevant. The scene in *Minority Report* is the ideal, where Tom Cruise is walking through the mall and there are ads that only he sees through his eyes, because they are targeted for him. Whether we actually reach that level, there are plenty of people in advertising for whom it's a very real aspiration.

"How do you start to refine the contextually relevant ad-model that marries content or content-consumption with needs and desires? This is where it's obviously going, because I can consume content whenever I want, in the amount that I want. Humans are changing the way that they relate to brands, and we're seeing it unfold in front of our eyes. Five years ago we were at a place similar to when television commercials were first introduced, the equivalent of that in the digital world. It's a fundamental change in the relationship between consumer, producer, and brand, not to mention the changes wrought on marketing strategies. We should all feel fortunate to be going through this wave."

Television Re-imagined

Marketers for Barack Obama's 2008 presidential campaign caused many in the advertising industry to sit up and take notice with their exploitation of the Xbox. Games like *Madden NFL '09*, *Burnout Paradise* and *Project Gotham Racing* take place in a simulated real-world environment, but ad-space is just real. It's also a smart way of putting a political message directly in front of a notoriously disinterested male audience. The Obama team not only realized this potential, with their virtual "Vote Obama" billboards, but incorporated an interactive element, whereby the ads encouraged gamers to text in to receive campaign updates on their real-life telephones (also, not incidentally, building the marketers' database of individual consumer information).

But this is the tip of the iceberg. The Xbox has gradually reconfigured the living room. The popular image of its user may be a Mountain Dew-swilling teenager in his mother's basement, playing *Call of Duty* for hours on end, but the amount of time spent watching entertainment on the Xbox now equates it to the third largest network in the U.S. Partly this is due to a concerted strategy of partnerships, with giant media outlets from ESPN to Hulu to Netflix; and partly it's due to straightforward Internet access, whereby one can update one's Fantasy League at the same time as watching *Saturday Night Live* on a Tuesday morning, at the same time as chatting with your grandmother, all from the comfort of the sofa through a single device.

This was not why Microsoft created the Xbox, however, just as no one at Nintendo expected the Wii to become one of the preferred teaching tools for surgeons. Through refinements to the user-TV interface, and particularly hand-control technology, what started out as a low-resolution image gamer console has ended up as a powerful media hub and distribution tool, with a huge variety of potential avenues for advertising. However, television is fast realizing that it doesn't even need that box between itself and the consumer. The development of the Internet-connected Smart TV promises to receive a tremendous boost when Apple's iTV is launched, conveying the convenience and designed sleekness for which their products are known to the traditional television room set-up, in full synch with the consumer's mobile devices.

BELOW: Obama campaign ad on Xbox "Burnout."

"Just as the consumer now has more power to create their own content, so too do the brands."

New Possibilities

Tesco has a virtual supermarket on a South Korean subway billboard, where commuters can scan QR codes of products, purchase them, and have them delivered within twenty-four hours. Limited edition Adidas sneakers are embedded with an augmented reality code that unlocks access to an online gaming environment, for which the sneakers act as game controllers. The technological possibilities are endless. Just as the consumer now has more power to create their own content, so too do the brands, and the emergent trend of branded content is something like a return to the early days of advertiser-sponsored television.

In the 1930s, Procter and Gamble sponsored radio drama (hence, soap opera); today they produce movies in partnership with Walmart. Following the success of *Laguna Beach*, and consulting with the Microsoft team, Coca-Cola decided to push the Sprite brand through its own scripted reality show. The question of how much reality was really useful, however, was endlessly debated. The targeted groups featured—five basketball players, five graffiti artists, and a five-member band—were given cameras to record their daily lives. Without some sort of directive, they tended to return footage of people eating pizza, with a Sprite can on the table; scripting not only allowed the participants still to display their individuality, but also for the marketing aims to be more focused.

Real people filming themselves has been a tempting path for advertisers. The power to produce video material is in the hands of anyone who can pick up a DSLR camera, and they have an immediate distribution network in the form of YouTube, or even Netflix, if the quality and business acumen are there. In the early days of YouTube, marketers quickly latched onto the viral video phenomenon, but almost as quickly learned that while the video is easy to produce, viral success is far less so. And so some have tried reverse engineering: taking an existing video that has achieved some measure of online success and harnessing it to the brand. They may need to buy it and polish it, but they don't have to come up with the idea, nor actually produce it themselves.

A notable development in this area is Doritos' nationwide contest to produce the commercial for their hugely prestigious Super Bowl slot. The truth of that contest is, however, that the successful submissions are not made by Joe and Mo Schmo in their living room, but by independent filmmakers or moonlighting industry professionals. And the retooling of existing Internet footage may be impressive in a campaign such as Verizon's "Batman" ads, but the vast majority of Internet videos cannot really be harnessed to the complex goals of trying to sell a deodorant. There is some first-rate material on the Internet, as is bound to happen given the sheer quantity; the technology may be out there for all to use, but the long and involved process of honing brand, message, and creative ideas to be conveyed via a very short film cannot be replaced by a cat swinging on a curtain.

An Industry Adapts

The advertising industry is supported by various trade associations who themselves have had to adapt to the new environment. The oldest in America is the Association of National Advertisers (ANA), founded by client-side marketers in 1911; the agencies are looked after by the 4As (American Association of Advertising Agencies); and supporting production companies since the mid-1970s is the Association of Independent Producers (AICP), whose members now account for eighty-five percent of all nationally televised commercials in the United States. Founded originally in response to a trend among advertising agencies to develop their own production entities, the AICP quickly extended its remit to include putting out guidelines and bid forms, as well as collectively bargaining union contracts, providing management and labor service management, and establishing health plans for freelance employees.

Matt Miller began with ANA in 1989, and since 1994 has been President and CEO of the AICP. One of the more complex issues that he deals with is the question of creative rights. Miller says, "The advertising industry follows a practice unusual in other industries, wherein the creators of content actually give away all rights by contract. The result is a notion—and a history—that as soon as one starts creating content, it's owned by the marketer. The rights go via the agency contract with the production company, to be given over to the marketer, the client company. In the U.S. especially that's rather a given.

"When you're doing video content it's pretty simple, because you have an image

BELOW: Doritos "Tracker" (Crash the Superbowl contest entry, Marcus Dunn and Jonathan Darden).

No animals, wives or children were harmed in the making of this commercial.

and you know exactly what you're talking about. Everything that's been created is right there, and it goes right to the client. When you get into the digital world, it's not that simple anymore because many of the things that you've created may rely on proprietary software that your company might have developed, or they can incorporate characters or other technologies that may be trademarked with your company. Think of Will Vinton Studios who created the claymation technique, and have copyrighted it as their own. [Vinton coined the term "claymation" for a little-used technique that he brought to prominence and popularity with his California Raisins ads in the mid-seventies.] Many things have gone into their campaigns that they simply can't, or shouldn't, give away. While the specific images of the California Raisins or whatever it happens to be clearly belongs

RIGHT: Adidas augmented reality sneaker, in use as a game controller.

to the client, all of the by-product and all of the technical pieces do not, and this is a tough thing for marketers to get their head around. They say, what do you mean I don't own everything lock, stock, and barrel? In the digital era they're still writing it into their contracts, that they own this, they own that, but they don't even understand what it means. They may own the digital files, but they can't do anything with them because they haven't got the software to unlock them."

This is one of many issues that led to the creation of AICP's digital guidelines in 2010, revised and updated in mid-2012. The AICP's original production guidelines cover eighty percent of issues found in the new digital working environment, but there are fundamental areas that were unimaginable decades ago when the guidelines were created for live action. The AICP has also found its membership swelled by a growing number of companies using exclusively digital means to create advertising content for distribution, such as animation companies, visual effects companies, and graphic design companies; these new types of advertisement are also being distributed by new types of company, specializing exclusively in digital media platforms and/or interactive media.

Matt Miller says, "Other things that came to light in the couple of years since the digital guidelines were first drawn up were payment terms and employment issues. Digital companies employ a far greater number of people for a prolonged period of time in very different capacities than live action companies do. It's a whole different workflow. But by now it's become a completely integrated part of the industry. More money is obviously being spent in digital media, so now that our definition of 'digital' has become interactive as well as describing production techniques. It's an area that's really exploding."

"What do you mean I don't own everything lock, stock, and barrel?"

Less Money, Less Time

Matt Miller says, "The Nike commercial is an exception. People are being tasked with trying to do jobs with shorter durations. We all know that it's difficult to do. There are only a certain number of hours in the day and there are certain complexities built in. The smarter agencies and marketers look at it and figure out better ways to plan and bundle the work that they want to do, rather than having expectations that you can just make a three-day shoot into a two-day shoot. But today one can get a larger amount of product out of a shorter amount of time—you might have a series of web ads, and you can shoot all of them in a couple of days. You bundle things together, presumably bundling multimedia; because the equipment has become so similar and the set-ups have become similar, you can potentially do a print shoot, three commercials, and a bunch of online stuff, which is the same set-up and job, and the same sets and the same talent.

"There's still going to be a lot of change. This is going to keep swirling. There are a lot of clients out there right now who are really playing with the idea, the notion they call 'decoupling,' particularly in America. It means that while the client can buy the creative content from the advertising agency, they don't actually need the advertising agency to execute: they'll engage the production company directly to execute, thus not having the traditional linear three-tiered model, but a sort of bifurcated thing where the client will manage the production side themselves and, as the theory goes, presumably save whatever compensation the agency would get for overseeing the production. And the agencies are not especially happy about this. While they don't make a great deal of money any more in most of their compensation deals from production, the flow of money is significant. So it does two things: however their finances work, it definitely bolsters their books; it also bolsters their overall balance sheets for showing what their billings are, which then affects their ability to borrow and so forth. There are a lot of financial implications if that money does not flow through the agency, above and beyond the profit they might make on that aspect of the overall industry.

"So the agencies are faced with two options: either to prove their superior creative power, or to harness some kind of production element that belongs specifically to them, which makes it advantageous for the client to continue using them for that part of the process. It's a really important crossroads that they're at, particularly as the client side of the business is becoming much more discerning in how much they spend and how they spend it, as the overall financial models and everything continue to evolve.

"We're definitely seeing more and more agencies being able to create their own content. Usually not for broadcast; usually it's when they're trying to stretch their dollars and they don't have a lot, and they're trying to get a lot of content on a website, and they'll just go out and shoot things. We're seeing more of that, and we're definitely seeing more agencies buying equipment and hiring individuals to do more post-production stuff in-house. More in the editing line than any high-end post—mostly recutting footage that they have and repurposing it. But at the same time we're also seeing more clients going directly to production companies because the marketers are trying to stretch their dollar, and they don't care in the same way about maintaining this full relationship with the agency. At a certain point they just want the creative product: so-and-so has done eight commercials within our campaign already, we've got five more, why do we need the agency? Just go directly and engage the director and execute these ideas.

"There's a little bit of experimentation in breaking and shifting the models that's

LEFT: Nike "Write the
Future" (Weiden+Kennedy/
Anonymous, Independent, d.
Alejandro Gonzalez Inarritu).

Sing Stock July 8, 2010 our beach version of Ronaldinho's step over trick 322,562

You Tube ronaldinho skills Search Browse Upload Create Accou

Our Wedding

Lucille Balls 11 videos Subscribe

1:40 / 3:00

Barrio Ball
72,000 views
Mr Jarnce

The Football Kid
150,979 views
Lucille Balls

Womens Soccer!
2,498,012 views
Luke Von Besten

Step Over and Mount
8,418 views
Wizbox 2010

Practice Makes Perfe
38,518 views
Frankie V

Step Over and Pass -
1,234,186 views
Ralpheroo

facebook Search Home Profile Account

Videos Posted by Laura McCabe

First | Next

Create an Ad

**Connect With More
Friends**

Share the Facebook
experience with more of
your friends. Use our
simple invite tools to start
connecting.

More Ads

Added 20 hours ago

374 people like this

Womens Soccer
by Laura McCabe (videos)
2:15

ABOVE AND RIGHT: Nike
"Write the Future"
(Weiden+Kennedy/
Anonymous, Independent,
d. Alejandro Gonzalez Inarritu).

WRITE THE FUTURE

definitely going on right now. The agencies are trying not only to conceive of but to execute in some ways some of the content, and yet production companies that are normally engaged just to execute are now helping to conceive of ideas, because these days, especially for digital media, the way you execute has so much to do with the creative idea to begin with. The production company can give a far better idea of what is possible and what is not. There are a lot of companies that have dubbed themselves 'digital agencies,' and the way they are structured is far more like a production company than like a traditional advertising agency, but with a strong creative component: their structure, the way they employ people, the numbers of people they employ, what their skillsets are, how they bill, all those things are much more in line with the practices of a production company than with that of an advertising agency, and project-based for the most part. It's interesting to watch, because as marketers get used to working with these digital agencies, they start to understand how they can engage production companies directly. It's shifting all over the place.

"Another change is that the client-procurement people have gotten involved in marketing in the last eight to ten years or so, and these are the people that, say for the car manufacturers, purchase sheet metal, or grease, or ball bearings. To them everything is a commodity, so it's become a very interesting and strange dialog because there are many things within the marketing, particularly within the creative process, that simply do not have a tangible, quantifiable value. It's creativity. Everything you do is a one-off. You can't find an average because everything that you're trying to do by its very definition is not average at all. It's above average, its different, it's a custom suit, it's not off the rack. So trying to look at those things and quantify them down into the normal purchasing practices of commodities doesn't work, and it's been a huge friction point on all levels of the business. It's one of those hard things over which agencies are trying to develop and change their relationships with the clients, because these people are clearly in control and have their hands around the marketing budgets, when they never did before.

"The pace of change and what is needed is not going to be settled at any point. It's not like twenty years ago when everybody basically understood print, outdoor, radio, and television. I don't think we're in a business where things are ever going to settle down."

"You can't find an average because everything that you're trying to do by its very definition is not average at all."

GLOSSARY

Animatic Assemblage of still images and short video to create a rough moving storyboard, often used to support a treatment when pitching for a job.

(Arri) Alexa Professional digital film-style motion picture camera, introduced by Arriflex in 2010.

ASC American Society of Cinematographers.

Brief The distilled outline of what the client wishes to achieve with an advertisement, in terms of content and communication to the audience.

Board Script equivalent, containing images, dialog, direction, and tone, to be used as a blueprint for the production phase.

Cannes Lions International Festival of Creativity Preeminent annual festival, awarding the finest international commercials.

CGI Computer Generated Imagery.

CMO Chief Marketing Officer.

Compositing The process of combining visual media such as filmed footage and CGI into a single image.

Craft services Area on set for snacks, drinks, etc.; also the department that provides this service, as well as general on-set support for the various departments.

DSLR Digital single lens reflex (camera), which became popular on the consumer market in the earliest years of the twenty-first century, capable of high quality still and video image capture.

Grading Treatment of video color in post-production, most usually to ensure consistency from shot to shot.

KPI Key Performance Indicator: a kind of self-assessment measurement used to track the success of strategy and performance.

P&L detailed financial statement of profit and loss, usually for a fiscal quarter.

Paid to Click An online business model whereby an advertiser pays to display advertisements on a Paid to Click website; as a way to generate traffic, members of the website earn a portion of this payment every time they click on an advertisement.

Pay per click An online business model whereby an advertiser pays the host website for every user who clicks on their commercial.

Plate A shot, or frame, set up and taken specifically and exactly for compositing in post.

Prepro meeting Preproduction meeting before the shoot, between all the creative talent involved behind the camera, from key

production crew to agency. All production details are covered and checked, from storyboard to wardrobe, casting, locations, and other visual references to the proposed look of the commercial.

Previs (ualization) Sketch-like video, sometimes also incorporating stills, to give an idea of the finished advertisement and, frequently, the effects that will be employed.

PSA Public Service Announcement.

Red camera HD digital motion picture camera, available in a range of models, with proprietary recording and processing technology.

Render Creating CGI; also, the processing stage required after effects have been added to video, in order to combine the massive amount of data involved for flawless playback.

Residuals Payments made to talent in front of and behind the camera for subsequent showings or screenings of the work.

Rotoscoping Originally an animation technique, adding drawn elements to filmed footage; now the general process of compositing effects on a live-action plate.

Saatchi & Saatchi New Directors' Showcase (since 1990) Concurrent with the Cannes festival, a showcase of the finest ads and directors in the world, as determined by the Saatchi & Saatchi agency.

Sensecam Small digital camera, which can be worn around the neck or elsewhere, that takes pictures automatically at predetermined intervals.

Treatment A synopsis of the proposed advertisement, containing reference to story and visuals, prepared by the director as part of the pitch to get a job.

VFX Visual effects, either in-camera or digitally-created.

Video village Area on set surrounding the camera-tap monitors, frequented by agency and client personnel, in order to observe and contribute to the shoot.

INDEX

ACKNOWLEDGMENTS

Thanks to

Roly Allen, Jamie Baldock, Leila Bartlam, Fredrik Bond, Kent Breard, Corran Brownlee, John Buckley, Kieron Connelly, Kate Donnelly, Kumar Doshi, John Ebden, Campbell Ferguson, Steve Gandolfi, Chris Harrison, Jennifer Jones, Nick Jones, Katie Keith, Daniel Kleinman, Jennifer Knox, Zara Larcombe, David Lyons, Darlene Mach, Bruce MacWilliams, Hilary Baum McQuaide, Matthew Miller, Luke Mugliston, Kirsty Oldfield, Jeani Rodgers, Carr Schilling, Dan Seddon, Georges Setten, Arturo Smith, Mya Stark, Hugo Stenson, Theresa Vaughan, Kristin Wilcha, Ellie Wilson, Helen Wilson